CHILDREN in ART

JANICE ANDERSON

SMITHMARK

This edition published in 1996 by SMITHMARK Publishers, a division
of U.S. Media Holdings, Inc., 16 East 32nd Street, New York, NY
10016.
SMITHMARK books are available for bulk purchase for sales promo-
tion and premium use. For details write or call the manager of special
sales, SMITHMARK Publishers, 16 East 32nd Street, New York, NY
10016; (212) 532-6600.

This book was designed and produced by Todtri Productions Limited
P.O. Box 572, New York, NY 10116-0572 FAX: (212) 279-1241

Printed and bound in Singapore

Library of Congress Catalog Card Number 96-68008

ISBN 0-7651-9944-0

Author: Janice Anderson

Publisher: Robert M. Tod
Designer and Art Director: Ron Pickless
Editor: Nicolas Wright
Typeset and DTP: Blanc Verso/UK

CONTENTS

INTRODUCTION 6

CHILDREN IN RELIGIOUS PAINTING 8

COURT PAINTING 20

FAMILY GROUPS 36

CHILD STUDIES 54

CHILDREN GROWING UP 80

CHILDREN AT PLAY 100

ARTISTS' CHILDREN 118

INDEX 126

INTRODUCTION

hildren are among the most difficult subjects for an artist to tackle. Their features are unformed, the bone structure of the face often hidden by the chubbiness of infancy; at the same time, their features can change, if not overnight, then very quickly so that an artist, perhaps commissioned to make a formal portrait, dare not take too long over it. Not that he always needs to: Thomas Lawrence, when taking on his first court commission, was told by a courtier that in his portrait of Queen Charlotte, consort of George III, he should 'be careful of individual likeness; in the princess [six-year-old Princess Amelia] you have more scope for taste, as the features will soon change from what they are at present'.

Children also have short attention spans and small reserves of patience, so that the artist almost certainly will not be able to indulge in long, concentrated sessions of work. If the artist has been specially commissioned to paint the child of an important personage, the strain can be enormous. When Anthony van Dyck began his first commission for King Charles I he found that the four-year-old Princess Royal refused to sit quietly, while the costume chosen for her

brother, the Prince of Wales, did not altogether please his royal father. Despite the difficulties, van Dyck persevered to produce some of the finest pictures ever painted of the British royal family.

A later painter working in England, the Swedish Michael Dahl, actually threw away his chance of being a painter to the court of George II; he was offered as his first subject the infant Duke of Cumberland and refused it because he was 'unwilling to begin with a child'.

Perhaps van Dyck had a good understanding of child psychology, something which Thomas Lawrence initially lacked. Lawrence was summoned to Windsor in 1789 to paint the family of George III (and asked to bring some specimens of his work and his 'painting apparatus' with him). Unfortunately, he got off to a bad start with Princess Amelia. He gave her eldest sisters two drawings, but for her there was only one. The little princess, most upset, ran to her father saying that she was sure Mr Lawrence did not like her as much as her sisters. Lawrence had to give her another drawing — and return another day to work on her portrait. The finished portrait, rather too pretty for present-day taste, pleased the princess's parents; there were more commissions for the artist, and, eventually, a knighthood.

Pierre Auguste Renoir, trying to complete a picture of his son Claude as a clown, found that bribery was the simplest answer to getting the child to pose. Claude Renoir's refusal to be over-awed by his father's great fame as an artist gives point to a remark by the artist Hugh Casson (made in his foreword to the book *The Child Art of Peggy Somerville*): 'Children and artists have one thing in common. They both believe they are the centres of the universe. This

cheerful obsession gives them the audacity to attack the apparently impossible.'

If the paintings in this book are any indication, a great many artists have discovered within themselves the audacity to attack, and overcome, the apparently impossible. Every one of the paintings and drawings here has something pertinent and truthful to say about children and their place in the world.

The pictures cover several centuries of Western art and reflect changing conditions and conventions both in the societies from which the children come and in the practice of art in those societies. They show, too, that great artists do not allow themselves to be shackled by convention and social acceptability, exploring behind the facades of fashion and custom to depict the true character of the person before them, whether an adult or a not-yet-fully developed child.

On a less elevated level, the pictures also show that children can inspire artists into painting wonderfully lively, carefree and colourful pictures. For, more than anything else, this book celebrates the joys and pleasures of childhood.

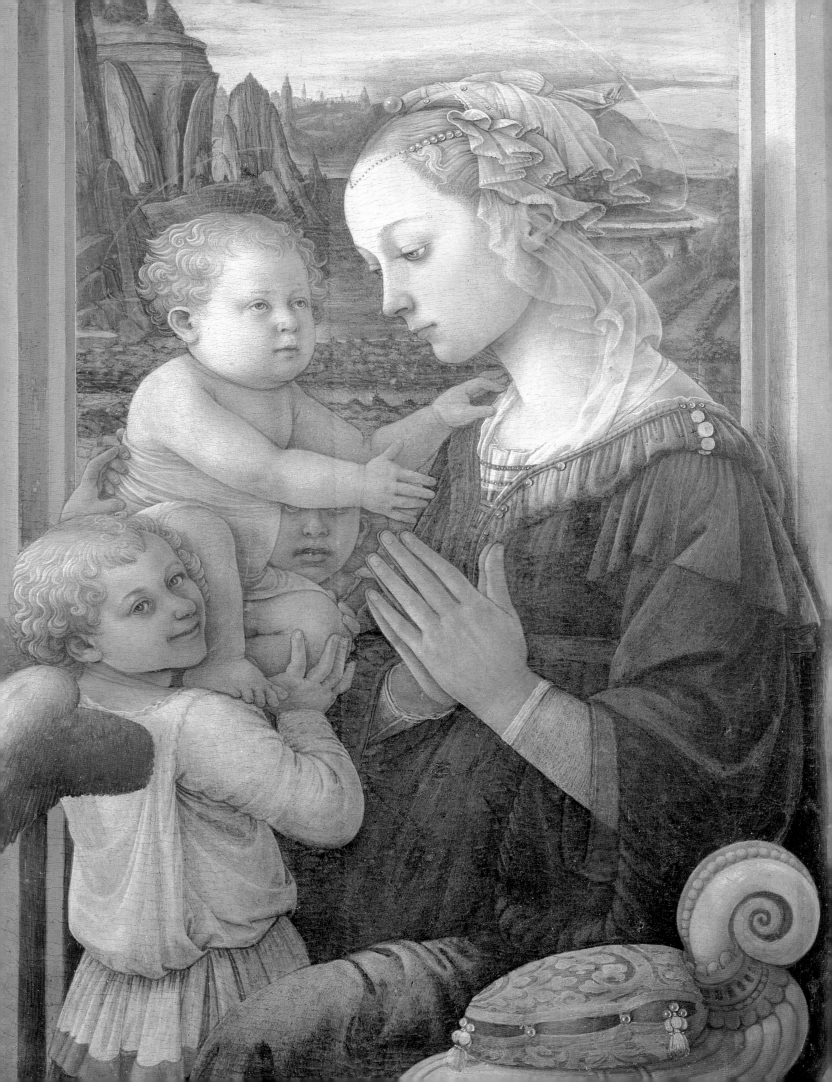

CHILDREN IN RELIGIOUS PAINTING

During the medieval and Renaissance periods in Europe, the Christian religion gave painting many of its main themes. Religion was important in the art of northern Europe, particularly in those countries which were closely linked, politically and historically, with Spain. In Italy, cradle of the Renaissance, it was the main theme.

A recent cataloguing of more than two thousand pictures painted in Italy between 1420 and 1540, when artists of the quality of the Bellinis, Fra Filippo Lippi and his son Filippino, Mantegna, Botticelli, Giorgione, Raphael, Leonardo da Vinci, Michelangelo and Titian were all working, revealed that the subject of eighty seven per cent of the pictures was religious, with almost half of them including the Virgin Mary, the Madonna, as the main focus of attention in the picture.

'Picture' is the right word to use in this context, for in Italy during the 15th century the representation of the Madonna and Child with Saints was taken out of the old polyptych form long used for church altarpieces, when each subject occupied its own panel of the complete work, and depicted instead in a style called Sacra Conversazione (Italian for 'holy conversation'). In this style, all the holy subjects of the picture, grouped together within one frame, were united in a common action or, if not, were at least all aware of each other's presence.

It was a style which lent itself to depicting religious subjects in a realistic setting and even, in the case of Carlo Crivelli's *The Annunciation, with Saint Emidius*, to uniting religion and politics. Crivelli's altarpiece, painted in 1486 to celebrate the granting of a measure of self-government to the town of Ascoli Piceno, is of particular interest here because the artist included in his wonderfully detailed street scene a little girl peeping round a corner at the top of a flight of steps to look at the angel and saint who have so miraculously appeared in the street outside the Virgin's window.

With so many pictures of the Madonna by so many great artists to choose from, finding pictures of babies and small children should be no problem. After all, where there is a Madonna, there must be, except in paintings of subjects like the Annunciation or the Assumption, a baby. But this is to forget the true purpose of religious art, as it had been for centuries.

When the creators of Byzantine mosaics, early medieval frescoes or Russian icons made pictures of the Virgin Mary and her child they were creating objects of devotion, highly stylized symbols the making of which demanded adherence to strict conventions. Thus, the Christ child could not be an ordinary baby, but must look like the Messiah he would become. The serious,

Opposite:
Fra Filippo Lippi (c.1406-69) **Madonna and Child with Two Angels** Date unknown, but after c.1450; Panel; 36 x 25in. (90 x 62.5cm.) Florence: Uffizi Gallery. Lippi's model for this lyrically serene Madonna was probably the nun Lucrezia whom he abducted and later married. Despite his early immoral behaviour, Lippi brought a deeply felt religious conviction to his later work, including this painting, in which the baby has the unchild-like face and form typical of most depictions of the Christ Child at this time.

Leonardo da Vinci (1452-1519)
Madonna with a Flower
(the **Benois Madonna**) 1478; Oil
on canvas transferred from panel;
19.3/4 x 12.5/8in. (49.5 x 31.5cm.)
St Petersburg: Hermitage Museum.
Leonardo was just 26 when he
painted this enchanting work
with its young and tenderly
smiling Virgin who displays a
truly maternal affection for her
son. Leonardo's depiction of the
Virgin was a startling break with
the iconographical treatment of
the subject still traditional in
Europe; his Christ Child, despite
the dimpled hands and fat knees,
remains an unlikely baby.

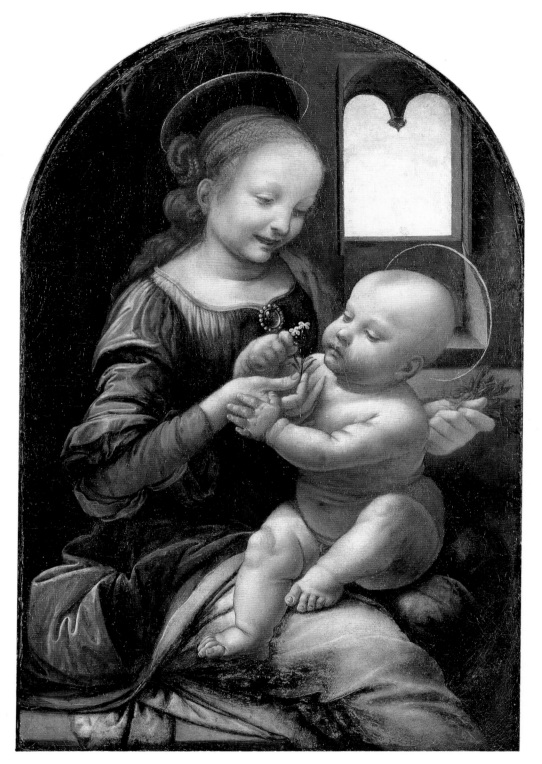

unsmiling expression on his face was there because it must prefigure the
inevitable death which was the child's destiny.

In a well-known example of a Byzantine icon, the *Madonna della Pace* in
the great Gothic Church of Santi Giovanni e Paolo (San Zanipolo) in Venice,
the Christ Child on the Madonna's knee, the two fingers of his right hand held
up in blessing, has the mature gestures and the face of an adult. He well illus-
trates the truth about many of the 'babies' in medieval and Renaissance reli-
gious art as they seem to us today: they are either strangely dwarfed adults,
often ugly both in face and form, or they are simply unconvincing as a depic-
tion of a child.

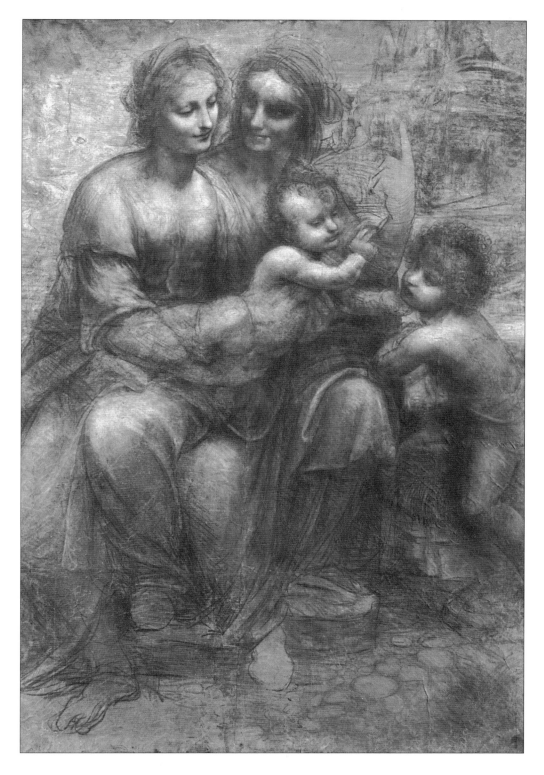

Leonardo da Vinci (1452-1519)
The Virgin and Child and Saint Anne and John the Baptist (the Leonardo Cartoon). *c.*1507-6; Charcoal, with white chalk heightening, on paper; 555/8 x 411/2in. (142 x 106cm.). London: National Gallery. This extraordinarily intense drawing, one of the 'most precious and fragile' works in the National Gallery, was done by Leonardo on eight sheets of paper glued together. The faces of the four figures, serene and sweetly beautiful, are perfect examples of Leonardo's work; the children, plump and curly-haired, are also uniquely his style.

Even when a greater naturalism and realism found its way into religious painting, partly with the increasing use of the Sacra Conversazione style and partly because artists were becoming more in sympathy with Classical Greek art and its emphasis on the human form, the traditional way of depicting the Christ Child continued.

Among early artists to break away from medieval conventions in religious paintings were the Bellinis, Jacoppo and his sons Gentile and Giovanni, who worked in Venice in the 15th century. Giovanni was the greatest innovator of the three, developing a wonderfully soft and naturalistic style in which his lovely, gentle Madonnas, depicted as real women rather than icons, seemed to

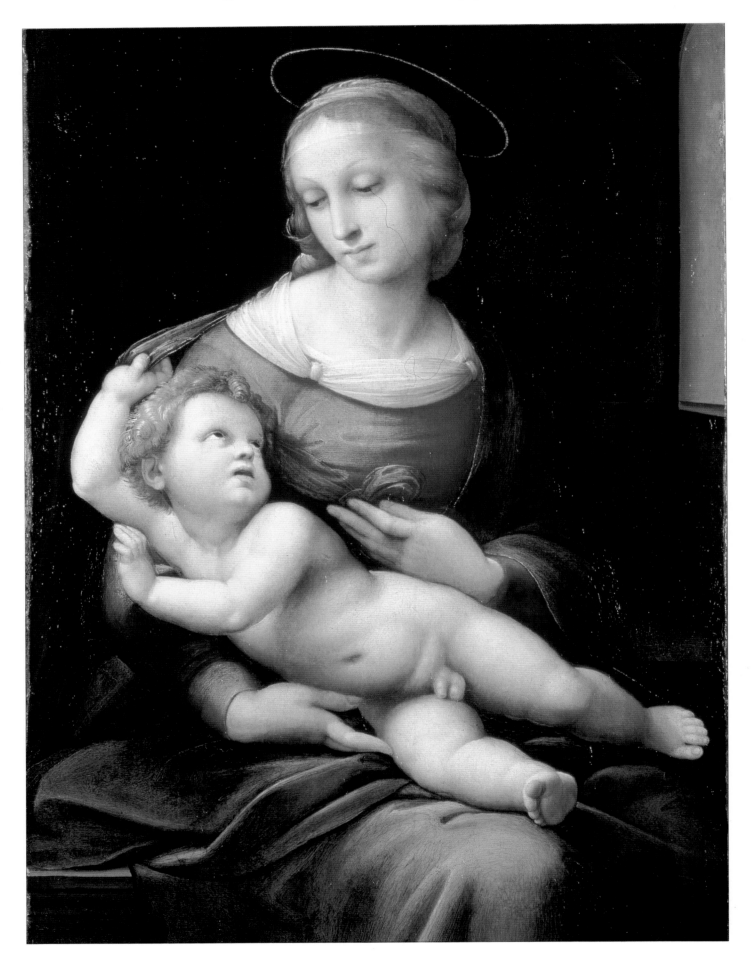

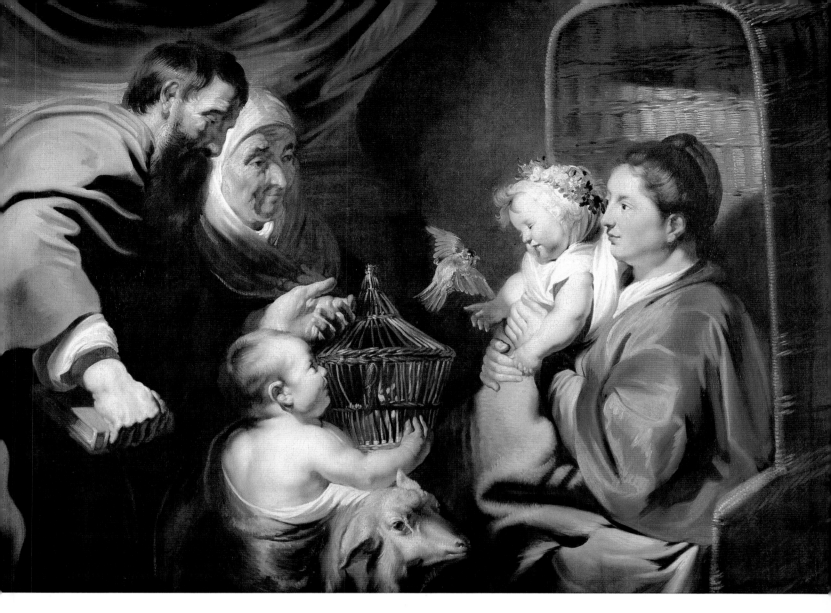

glow with a golden warmth. The Christ Child did not fare so well.

In Giovanni Bellini's luminous *The Madonna of the Meadow*, for instance, the Child, set awkwardly across the Madonna's lap, looks much too large. Although his hands and feet have an acceptably baby-like dimpled chubbiness, his face, with its closed eyes, is that of an old man. Nor does Bellini's new naturalism extend to a clear portrayal of the Child as a boy baby.

For much of the Renaissance period, the Christ Child, although usually depicted naked, was seldom realistically painted as a male child. An outstanding exception is Antonio Corregio's wonderfully tender *The Madonna of the Basket*, painted about 1524, in which the artist painted a real little boy with a bare bottom and genitals and kicking his feet in the air. But for Fra Filippo Lippi's several depictions of the *Madonna and Child*; for Botticelli's *The Madonna of the Pomegranate*, *The Madonna of the Book*, and numerous others; for Mantegna's superb altarpiece, *The Virgin and Child with the Magdalen and St John the Baptist*, there was always a strategically placed knee or hand, or pieces of drapery allowed to float across the Child's belly, to disguise reality. As late as the mid-17th century, the Antwerp artist, Jacob Jordaens still found it necessary to drape a string of beads across the Christ Child's belly in one of his pictures of *The Holy Family*.

The main reason for this reticence was that paintings of religious subjects were still fulfilling a dual role. They were both devotional aids and important items of religious education at a time when the majority of people could not read, or had no devotional books available to them. As Ludovico Dolce, a

Jacob Jordaens (1593-1678) **Mary with the Christ Child and Saints Zachary, Elizabeth and John the Baptist**. Oil on canvas; 443/4 x 591/2in. (114 x 151.8 cm.) London: National Gallery. The leading painter in Flanders after the deaths of Rubens and Van Dyck, Jordaens based his art on everyday life.

Opposite:
Raphael (Raffaello Sanzio) (1483-1520) **Virgin and Child** (the **Bridgewater Madonna**). Date unknown, but after 1507; Canvas transferred from panel; 321/2 x 221/2in. (81 x 56cm.). Edinburgh: National Gallery of Scotland. Reducing his background to a window, Raphael concentrates all his attention on the Virgin Mary and her Child.

Bartolomé Estebán Murillo
(1617/18-82) **The Holy Family
with the Little Bird** *c.*1650; Oil
on canvas; 561/2 x 721/2in.
144 x 185cm.) Madrid: Prado
Museum. In this fine evocation of
a happy family life, painted with
a simple realism, Murillo depicts
Jesus as a delightful little boy.
The expression on his face is
sweetly tender, but free of any
sentimentality. Although Murillo
has given his work a religious
title, he adds no other details to
suggest the divine nature of the
people he is painting with such
gentle charm, even playing down
the significance of the traditional
theme of the Christ Child with a
bird, symbolizing His Passion,
by introducing a lively little dog
into the scene.

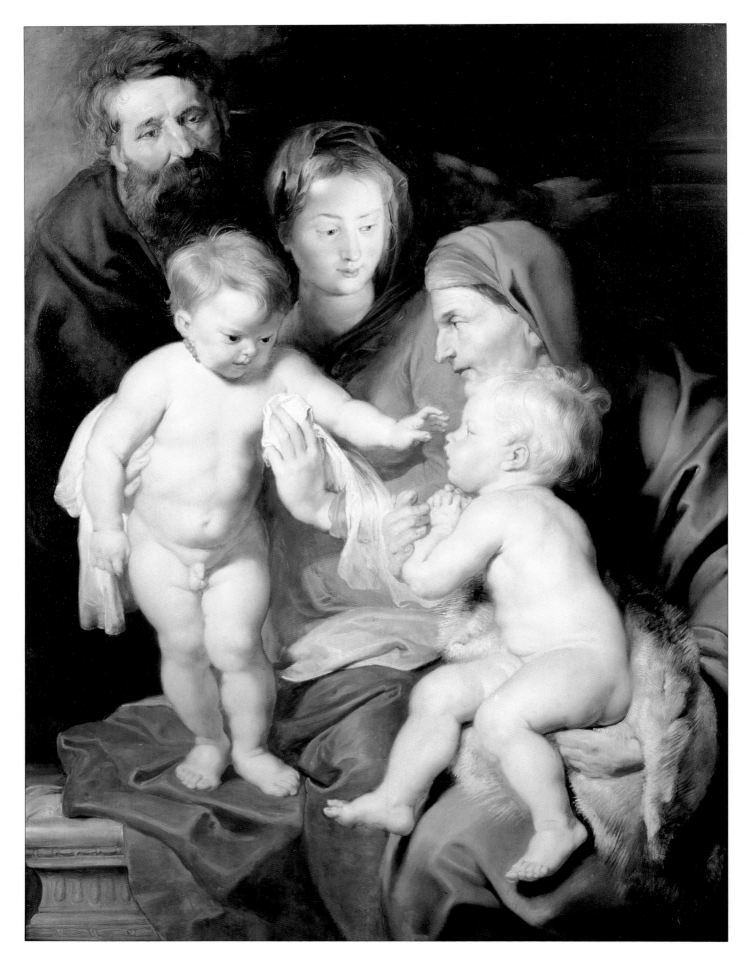

contemporary of Titian, noted, paintings which illustrated incidents in the lives of the Holy Family and of the saints were 'of great benefit to the devout Christian, in awakening his imagination, fixing his attention, and raising his ideas to heaven.'

The great artists of the later Renaissance, including Leonardo da Vinci, Raphael and Titian, while continuing to observe the conventions demanded by contemporary society, brought to their painting of religious subjects, including the Christ Child, a greater realism and a stronger emotional content which, in fact, helped educate the devout Christian into accepting 'real' children, rather than icons, in religious painting.

By the 17th century, when Peter Paul Rubens did not hesitate to use his own children as models for Jesus and John the Baptist and even the dimple-bottomed cherubims in his many superb paintings of religious subjects, the Christian religion in Europe had divided itself along Catholic/Protestant lines. More extreme Protestants regarded material aids to prayer, especially ornaments and pictures, as idolatrous and as coming between man and God. The Catholic church of the Counter Reformation viewed art very differently. A fine painting, to a Roman Catholic, could in itself be a manifestation of the goodness of God, as well as an inspiration and help to the worshipper, whether in church or in his own home.

While religious subjects, taken from both the Old and New Testaments of the Bible, were, of course, still painted by artists living in Protestant countries, the Dutch painters Rembrandt van Rijn and his one-time pupil Nicolaes Maes among them, it remains true that many of the finest examples of children in religious painting in the 17th and 18th centuries are to be found in Catholic countries.

A good example is the 17th-century Seville-born Bartolomé Esteban Murillo, an artist whose reputation in Spain and beyond was second only to that of Velázquez. Murillo's work, much of it in a soft, gently sweet style called *estilo vaporoso*, had a great influence on religious and genre painting, as well as on the painting of children, until well into the 19th century. In paintings like *The Children with the Shell* (also called *Jesus and St John the Baptist as Children*), *The Holy Family with the Little Bird* and *St John the Baptist*, the children are depicted with a gentle charm and an innocent dignity. Murillo's pictures manage to be both portraits of real children and acceptable depictions of two of the most important figures in the Christian religion.

Depicting religious figures with realism while not offending religious sensibilities long remained a difficult balancing act for an artist, nowhere more so than in England, even in the mid-19th century. The reception given John Everett Millais's *Christ in the House of His Parents*, exhibited at the Royal Academy in London in 1850, was extraordinarily hostile.

Millais, as a true Pre-Raphaelite committed to depicting the immediate reality of his scene, went into great detail in the picture. The painting shows Jesus, Mary and Joseph, with two other workers and a boy, presumably John the Baptist, for he has a sheepskin draped round his waist, in a carpenter's shop. Jesus, a solemn boy, is apparently about to comfort his mother with a gentle kiss, having shown to her the blood of a wound on the palm of his hand; there is also a blood-stained wound on his foot. Joseph is holding his son's wounded hand, an expression of concern on his face.

'Mr Millais' picture is, to speak plainly, revolting,' thundered *The Times*. 'The attempt to associate the holy family with the meanest details of a carpenter's shop, with no conceivable omission of misery, dirt or even disease, all finished with the same loathsome minuteness, is disgusting.'

Charles Dickens was particularly offended by Millais' depiction of the Virgin Mary. She looked like 'a monster in the vilest cabaret in France or the lowest

Opposite:
Peter Paul Rubens (1577-1640)
The Holy Family with Saints Elizabeth and John the Baptist
*c.*1614; Oil on panel;
54 1/4 x 40in. (138.4 x 102.2cm.)
London: Wallace Collection.
Rubens here foreshadows the baptism of Christ by John the Baptist. His painting depicts the elderly Saint Elizabeth holding her son, John the Baptist, on her knee, while the baby Jesus holds his hand up in blessing. Both children, toddlers rather than babies, are painted realistically and also with a tender regard for the special attractions of small children.

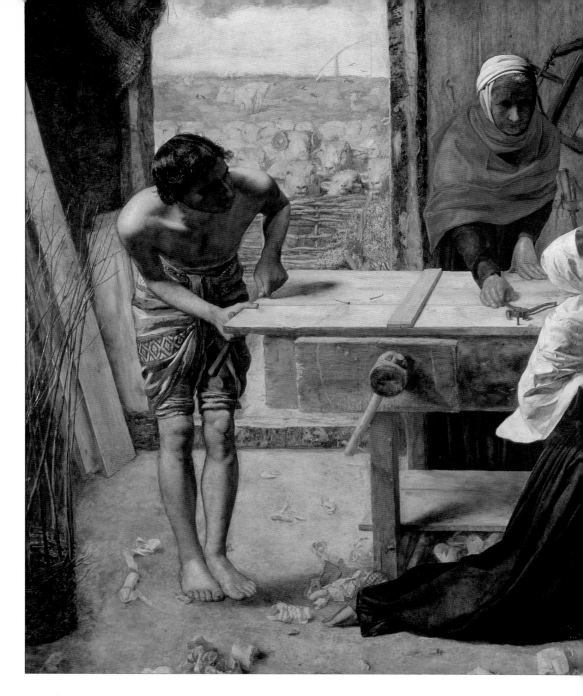

gin-shop in England,' he told the readers of *Household Words*.

This attack on Millais' work, a serious attempt to depict with dignity an aspect of the early life of Jesus, seems all the more hypocritical when we remind ourselves that at this time many of the so-called 'genre' artists of the day, in Europe and North America as much as in Britain, were presenting the child's connection with religion as a saccharine-sweet social activity.

It needs to be said, however, that Millais' own approach to the painting of religious subjects was not free of the distinctly 'white-Anglo-Saxon-Protestant' hypocrisy which marked so much religious art in the Victorian age. He never tackled the only theme in religious art which linked children with the Bible. This was the theme of *Christ Blessing the Children*, which was based on Christ's words, as reported in St Mark's Gospel: 'Suffer the little children to come unto me and forbid them not: for such is the Kingdom of heaven.'

The subject had been painted in the 17th century by the Dutch artist Nicolaes Maes and in the 19th century by Sir Charles Eastlake, a President of the Royal Academy. Millais chose not to tackle it because to paint it with a realism sufficient to meet the requirements of the Pre-Raphaelites he would have to show the children as 'the brown simious-looking children of Syria'

rather than 'our own fair English children'.

Not that Millais treated all his religion-linked pictures seriously. In *Her First Sermon*, he pictured a solemn-eyed little girl, her hands tucked decorously into a muff, sitting alone and carefully upright in a heavy wooden church pew. In a companion picture, *Her Second Sermon*, the little girl has dozed off in the middle of the sermon. For lesser artists in the 19th century, painting pictures with a religious theme came to mean avoiding painting characters and stories from the Bible in favour of picturing religion as a social activity. Families could be depicted saying prayers at home, or reading the Bible together, or walking to church together on Sunday morning. When depicting children in the context of Christianity, Christmas time, for instance, became an excuse, not for depicting the Christ Child in his manger, but for painting pictures of children dancing round a Christmas tree, helping stir the Christmas pudding or singing carols outside holly-decorated front doors.

There was even a popular sub-category of the child-painting genre in 19th-century Europe concerned with painting scenes in church vestries, often involving the choir boys getting up to mischief. It seemed a long way from the old belief that art helped raise the devout Christian's eyes heavenwards.

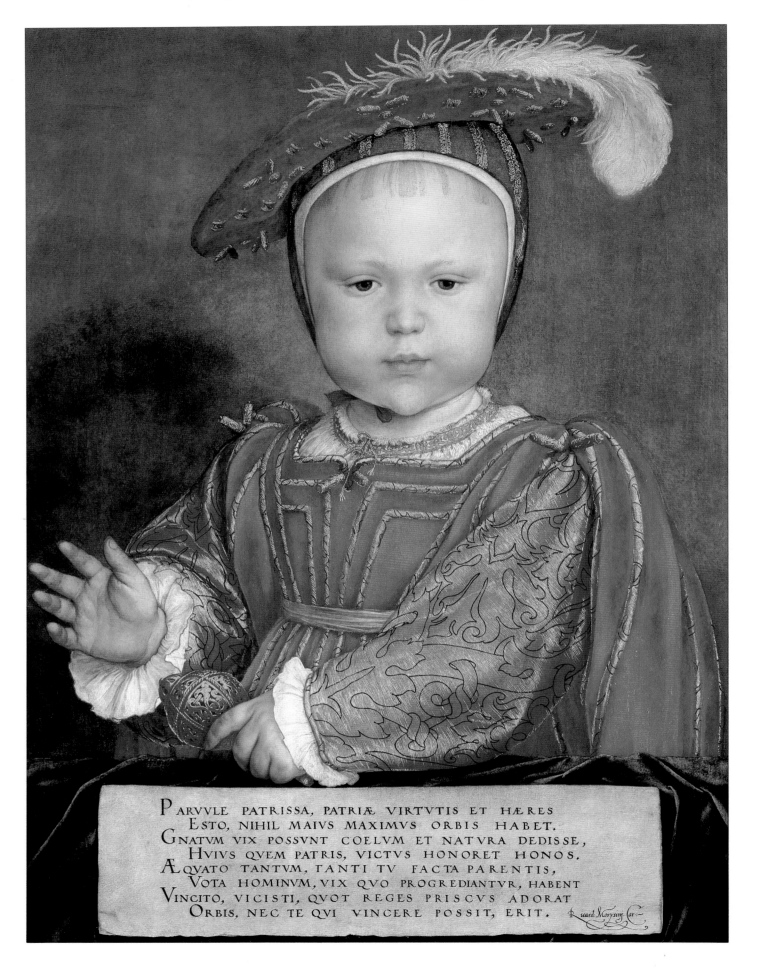

PARVVLE PATRISSA, PATRIÆ VIRTVTIS ET HÆRES
ESTO, NIHIL MAIVS MAXIMVS ORBIS HABET.
GNATVM VIX POSSVNT COELVM ET NATVRA DEDISSE,
HVIVS QVEM PATRIS, VICTVS HONORET HONOS.
ÆQVATO TANTVM, TANTI TV FACTA PARENTIS,
VOTA HOMINVM, VIX QVO PROGREDIANTVR, HABENT
VINCITO, VICISTI, QVOT REGES PRISCVS ADORAT
ORBIS, NEC TE QVI VINCERE POSSIT, ERIT.
Ricard Morysin Car.

\mathscr{C}OURT \mathscr{P}AINTING

\mathscr{T}he Renaissance period was a time of great social change as well as artistic ferment. People looked at themselves and their place in society with a fresh eye. For the leaders of that society, the kings and princes, dukes and counts, how they themselves were presented to the peoples they ruled became a matter of paramount importance.

From feeling that 'the satisfaction of seeing the effigies of his ancestors is of the greatest value to any man,' as the artist and art historian Giorgio Vasari put it, those in power in Europe came to be almost as concerned about how they and their heirs were presented to their peers and their subjects as they were about what future generations thought of them. Future generations mattered, too, of course, for these princes and rulers saw themselves as establishing dynasties: thus the importance of having their sons' and daughters' portraits painted as well as their own.

Many early portraits of dynasties like the Medici of Florence were in frescoes, the most celebrated of which may be seen today on the walls of the Camera degli Sposi in the Ducal Palace at Mantua. The magnificent frescoes painted here between 1465 and 1474 by Andrea Mantegna illustrate the life of Ludovico Gonzaga, one of the greatest art patrons among the princes of the Renaissance, his wife, Barbara of Brandenburg, and their very large family.

With so many great people to be included in the three scenes into which the frescoes are divided, including a cardinal, two kings and the Holy Roman Emperor as well as numerous members of the Gonzaga family, it is not surprising that Ludovico Gonzaga's young son and daughter have been given comparatively little space — no more than that allotted to the family's dwarf and favourite hound; they are at the centre of the main scene, however, an indication of their importance in the great game of dynasty-making in Europe.

Great princes had long been portrayed in other ways, but now, having their profiles on coins or on the portrait medals which continued a tradition dating back to imperial Rome was no longer enough. Portraits were what mattered, and not just the traditional profile portrait. If a portrait was to allow for any interpretation of the nature of man — a main preoccupation of the Renaissance — then it would have to be full face.

The development of the easel painting brought a practical benefit: unlike wall frescoes, they could be moved about. Princes could bestow their portraits on other princes, or send attractive pictures of their daughters to the fathers of possible marriage partners. One of the young Rubens' first diplomatic missions involved the taking of portraits from his patron, the Duke of Mantua to King Philip III in Spain.

Opposite:
Hans Holbein the Younger (1497/8-1543) **Edward, Prince of Wales** c.1538; Oil on panel; 223/8 x 173/8in. (56.8 x 44cm) Washington, DC: National Gallery of Art, Andrew W. Mellon Collection. This is the earliest-known portrait of Henry VIII's only son, born to the king's third wife, Jane Seymour, in 1537. The painting is thought to be identical to another which Holbein gave Henry VIII as a New Year gift in 1539, the king giving Holbein a gold cup in return.

Overleaf:
Hans Eworth (active in England 1549-c.1574) **Henry Stewart, Lord Darnley** 1555; Panel; 291/2 x 22in. (74 x 55.2cm.) Edinburgh: Scottish National Portrait Gallery. Henry Stewart, Lord Darnley was ten years old when he sat for his portrait by the Antwerp-born artist, Hans Eworth, who worked mostly in England. As befits one closely allied to the Scottish and English royal families, the boy is portrayed as mature for his years. Twelve years after the portrait was painted, Lord Darnley was dead, murdered, it was whispered at the time, at the instigation of his wife Mary, Queen of Scots.

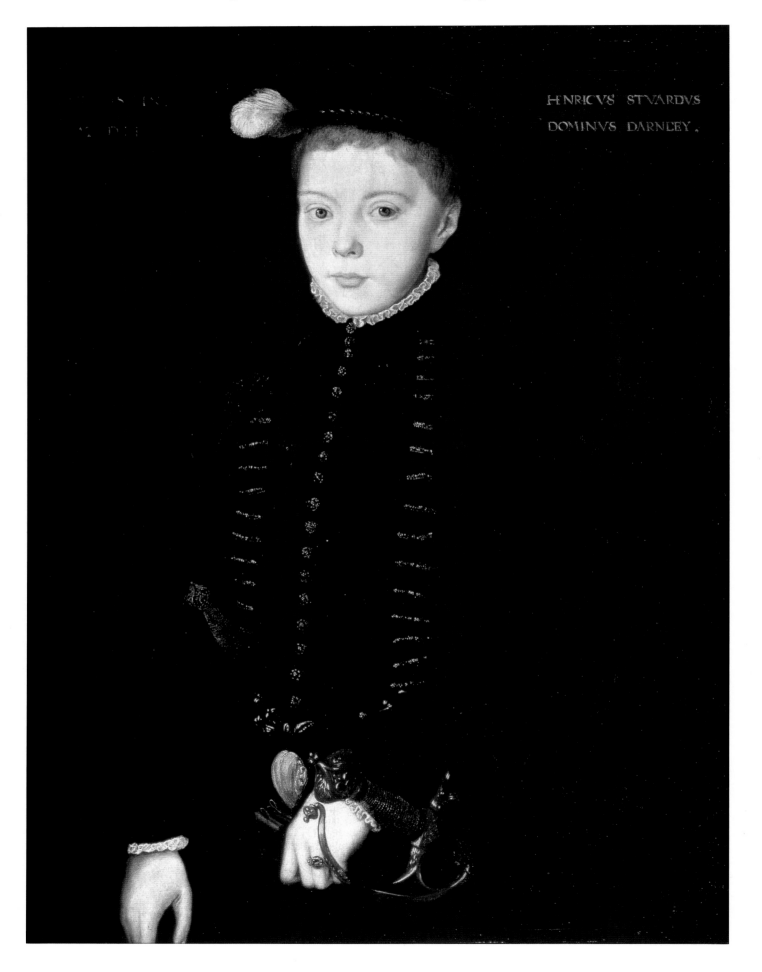

HENRICVS STVARDVS
DOMINVS DARNLEY.

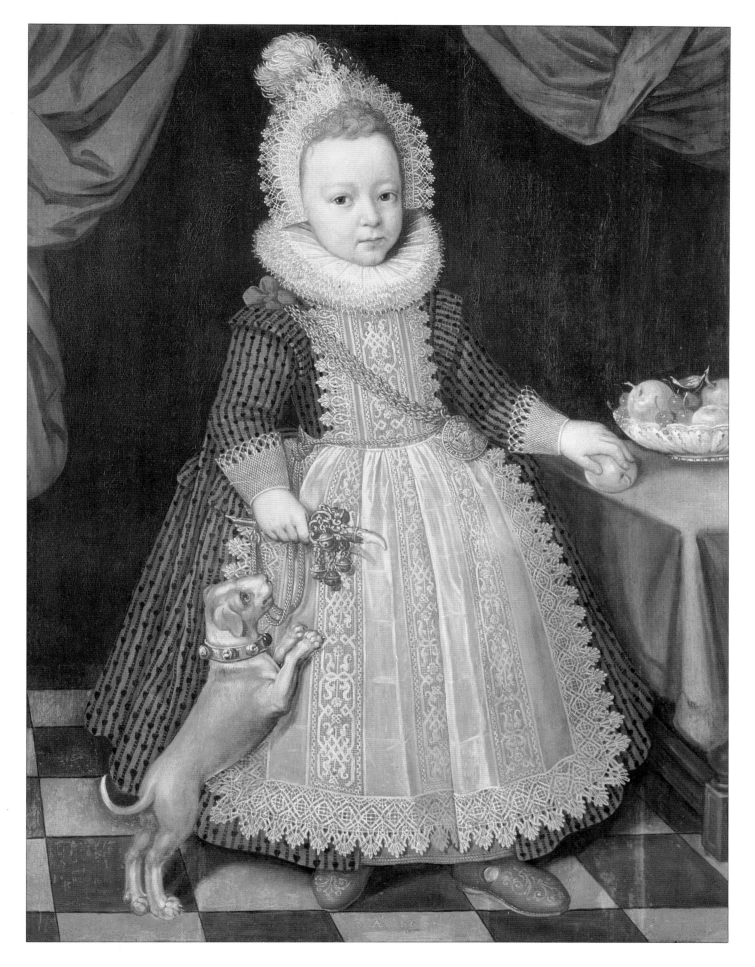

Previous page:
Paul van Somer (c.1576-1621/2)
**Princess Elizabeth, daughter of
James VI and I** *c.*1600; Panel.
Leeds: Temple Newsam House.
The Princess Elizabeth was born
in Scotland in 1596, and so
would have been just four when
this richly detailed portrait was
painted. She was brought up in
England after her father became
king of England as well as
Scotland in 1603. Her marriage
to the Protestant Elector Palatine,
later king of Bohemia, brought
her the romantic title of 'Winter
Queen' but also much hardship
and poverty when her husband
was forced off his throne by the
Catholic League.

Right:
Anthony van Dyck (1599-1641)
**The Children of Charles I -
Princess Elizabeth and Princess
Anne.** 1637; Oil on canvas;
113/4 x 161/2in. (30 x 42cm.)
Private collection.Although what
looks like a 17th-century hand
has inscribed 'Henry Duke of
Glocester' on the baby's shoulder,
Oliver Millar, former Surveyor of
the Queen's Pictures, has pointed
out that this cannot be correct.
Van Dyck did the painting from
life as a study for his famous
Five Eldest Children of Charles I,
painted in 1637, two years before
Prince Henry was born.

Overleaf Left:
Titian (Tiziano Vecellio)
(*c.*1488/90-1576) **Portrait of
Ranuccio Farnese** 1542;
Oil on canvas; 351/4 x 29in.
(89.7 x 73.6cm.) Washington,
DC: National Gallery of Art,
Samuel H. Kress Collection.
Titian's supreme genius as a
portrait painter is well
demonstrated in this superb
study of the boy princeling from
the ruling family of Parma,
Ranuccio Farnese.

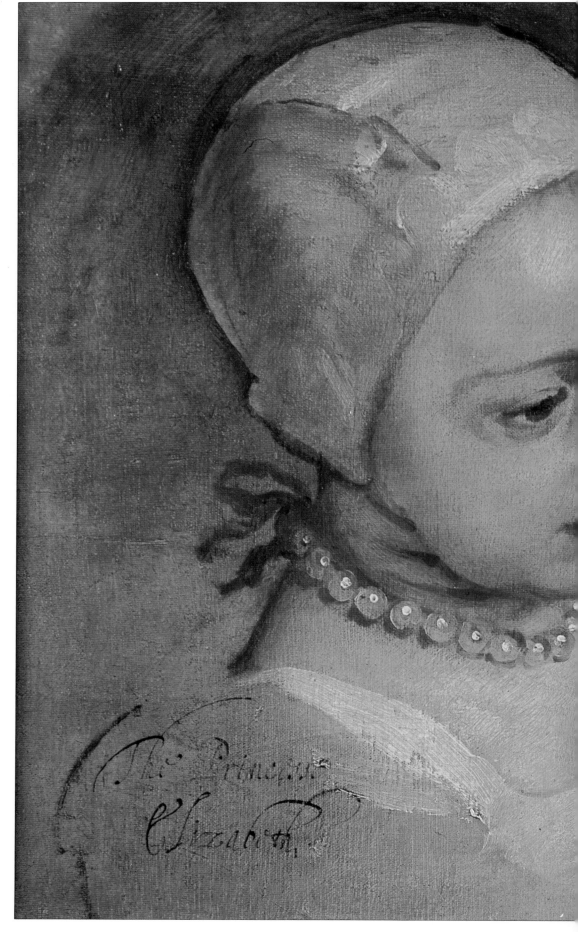

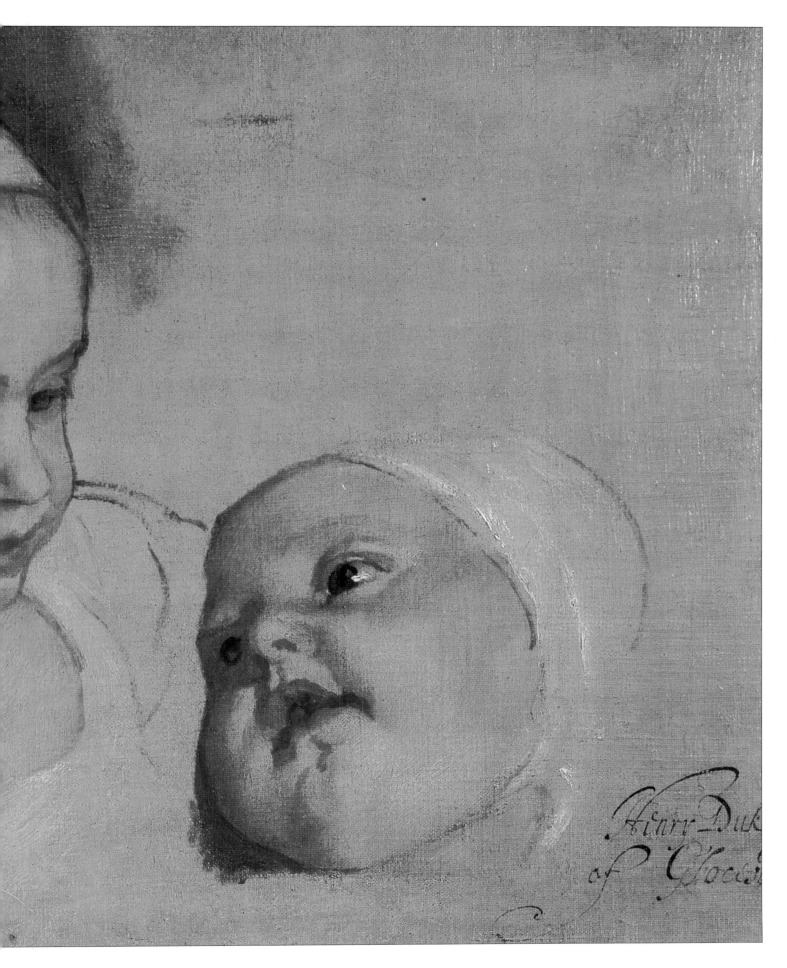

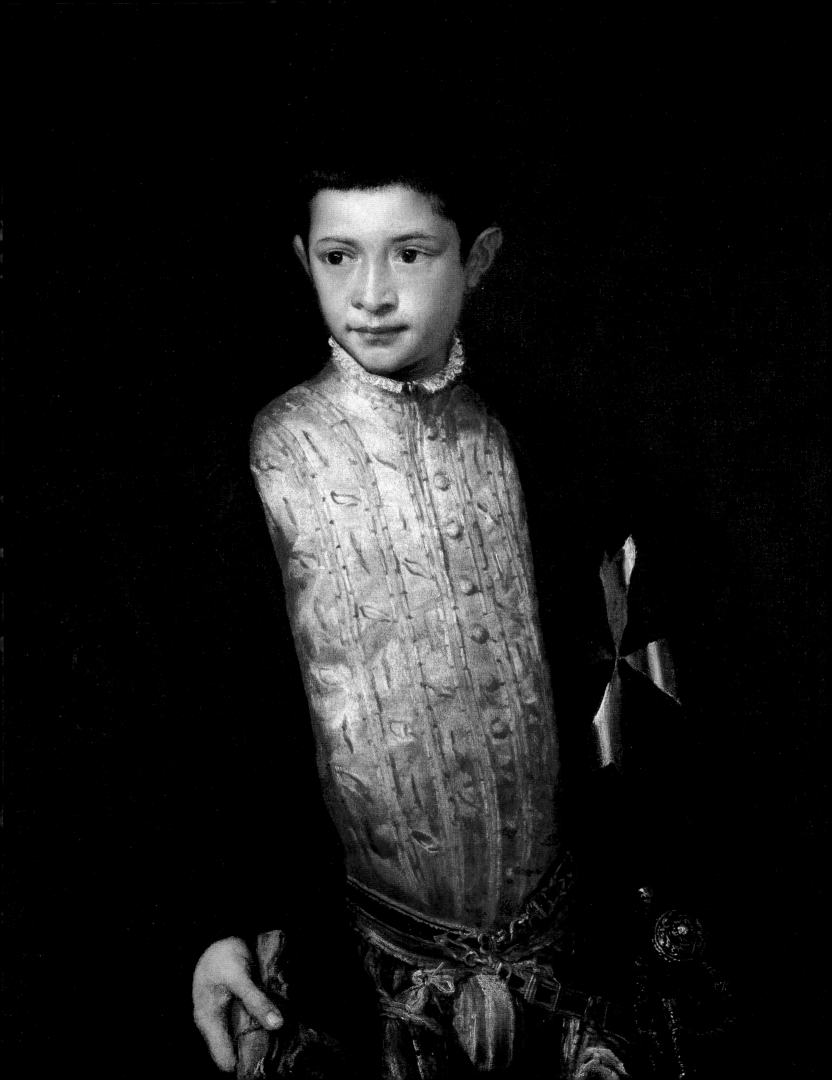

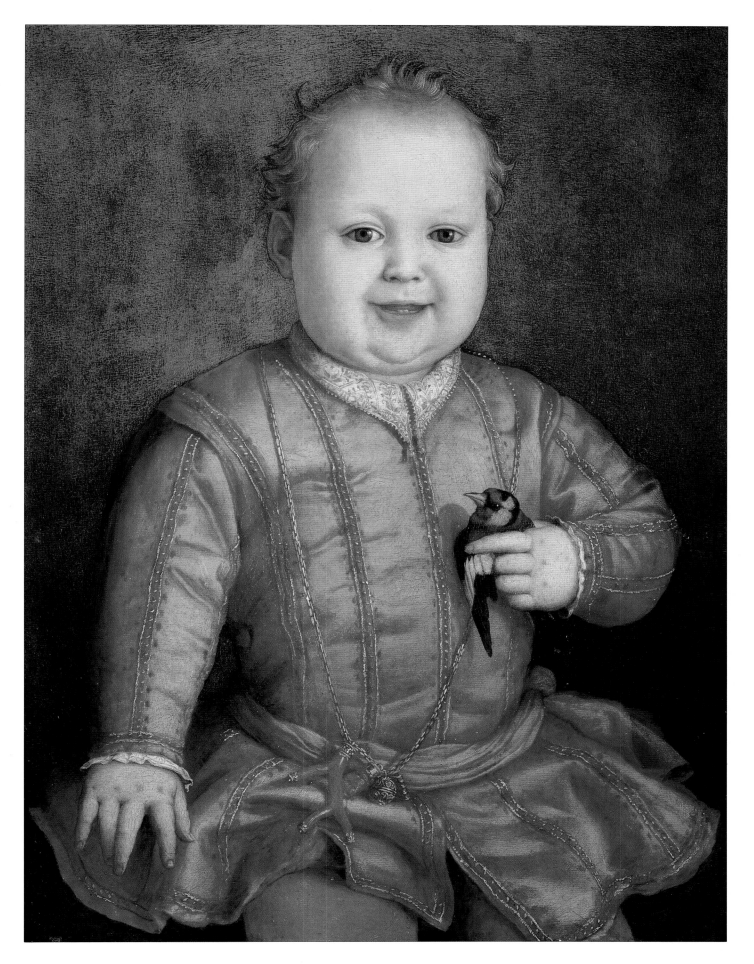

The use of oil in artists' colours, an innovation which reached Italy from Flanders during the 15th century, allowed for an increasing subtlety and great variety of tone and texture in portraits. These characteristics are all evident in the work of one of the best European court painters of the 16th century, Agnolo Bronzino, court painter to Cosimo I de' Medici in Florence. Among his best works are several lively and characterful portraits of the children of the Medici clan, including the chubby and cheerful *Don Giovanni de' Medici*, painted with a bird in his hand.

In the hands of later masters like the Venetian Titian, Rubens or Rembrandt in the Netherlands, Velázquez and Goya in Spain, portrait painting could reach breathtaking levels of subtlety and insight.

Previous page:
Agnolo Bronzino (Agnolo di Cosimo) (1503-72) **Don Giovanni de' Medici** c.1545-6; Panel. Florence: Uffizi Gallery. Bronzino was Court Painter to Cosimo I de' Medici, the first Grand Duke of Tuscany, and produced many superb portraits of the Medicis, most of them in the coolly aloof, exquisitely detailed style of Mannerist court painting: which is why this portrait of a Medici child is so memorable. Chubby Don Giovanni has a jolly smile on his face, though Bronzino has also hinted at a certain aristocractic indifference to others about him.

Opposite:
Diego Rodrigues de Silva Velázquez (1599-1660) **The Maids of Honour (Las Meninas)** 1656; Oil on canvas; 125 x 118½in. (318 x 276 cm.) Madrid: Prado Museum. Velázquez's masterly composition, recording a visit of the Infanta Margarita and two of her maids of honour to the artist's studio in the royal palace in Madrid, is one of the earliest depictions in Spanish art of the theme of the family group.

Right:
Diego Rodriguez de Silva Velázquez (1599-1660) **The Infanta Maria Theresa** c.1659; Oil on canvas. Vienna; Kunsthistorisches Museum. Even the ugly farthingale holding out her skirt and the baroque pomposities of curls, ribbons and pearls cannot disguise the simple charm of the young Spanish princess who married Louis XIV of France the year after this portrait was painted. This is one of several memorably impressive portraits of the family of the Philip IV of Spain done by Velázquez which were sent as gifts to the Austrian Imperial Court.

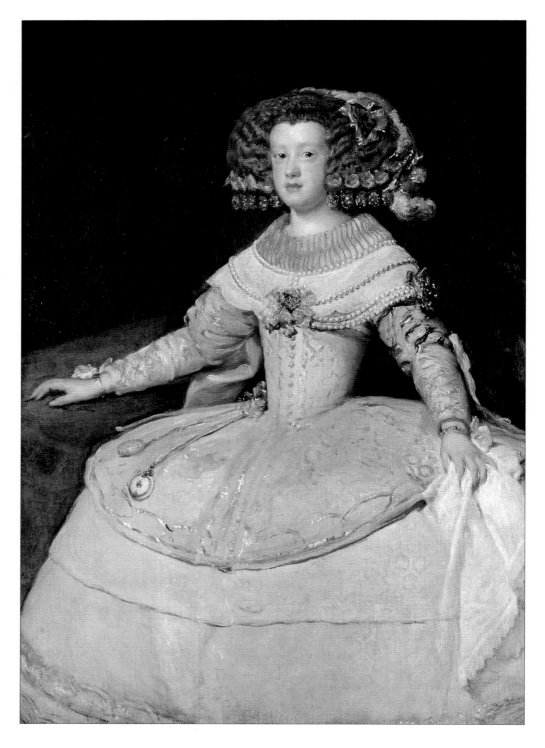

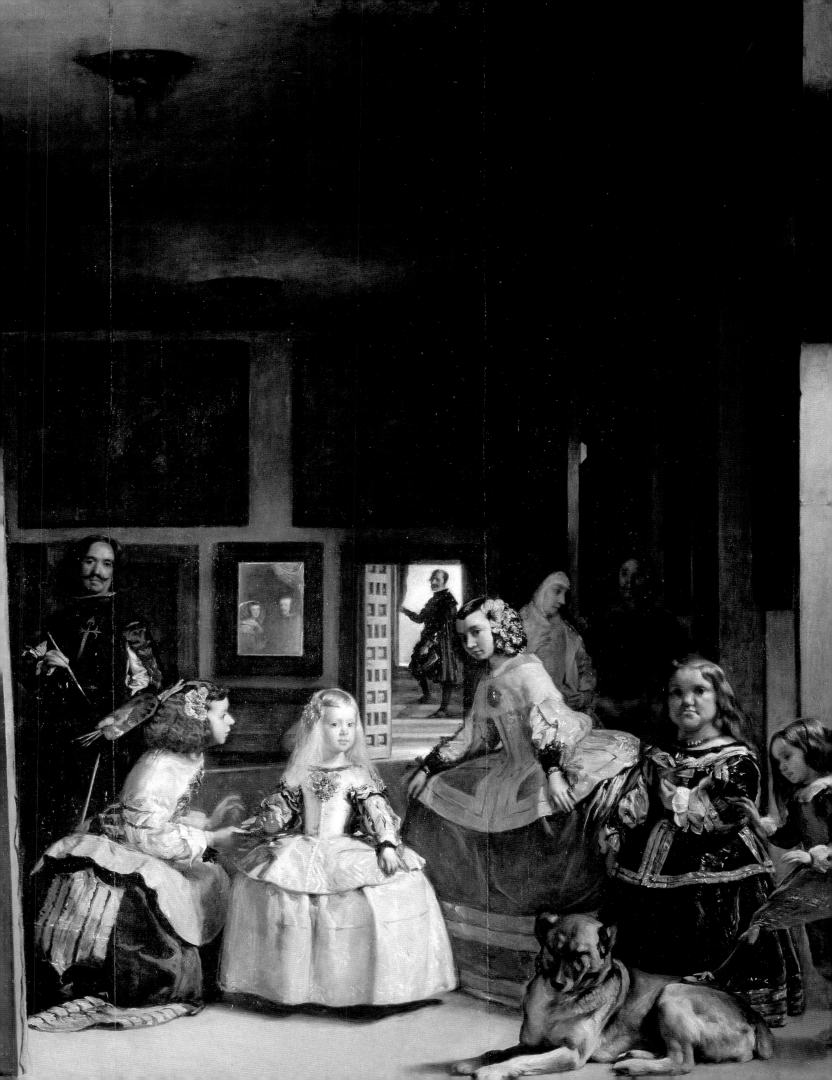

Although only about eight years old when this portrait was painted, Princess Elizabeth (1692-1712), a daughter of James VII and II, has been portrayed by the French painter Largillière as a small adult.

Of George III's and Queen Charlotte's fifteen children six were girls. After seeing all the princesses together in 1787, the writer Fanny Burney wrote 'Never, in tale or fable, were there six sister Princesses more lovely.'

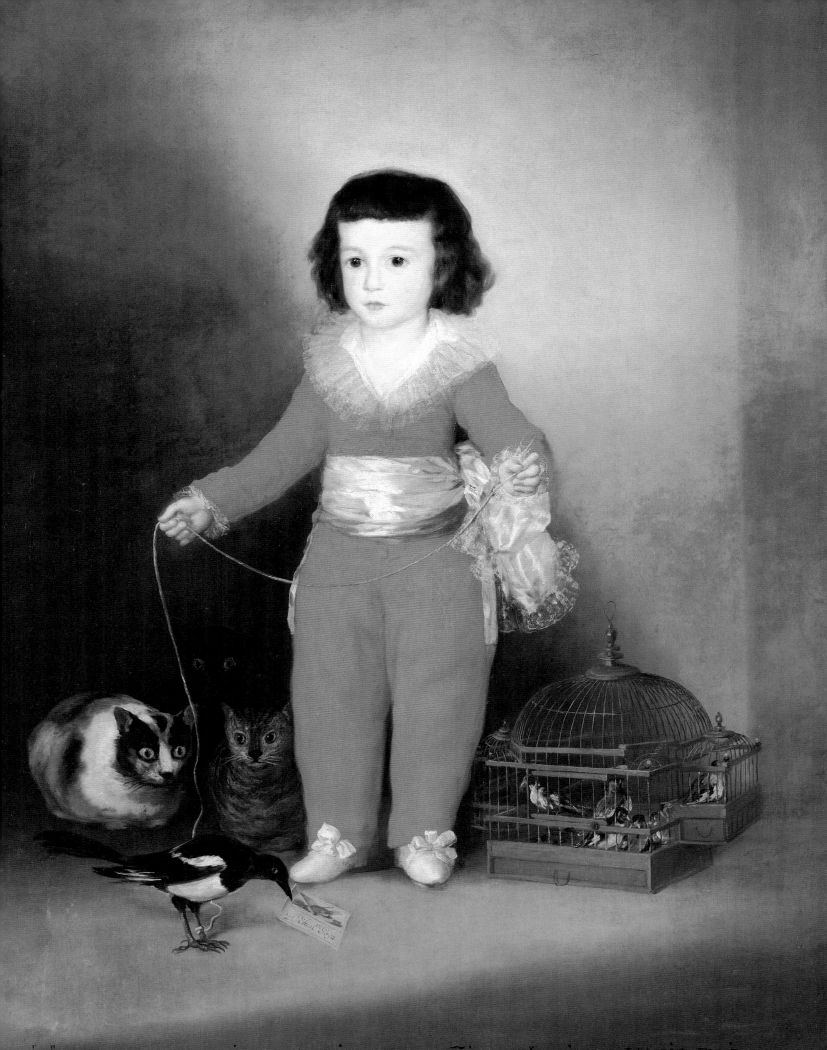

LS.ᴰ.ͬ MANVEL OSORIO MANRRIQVE ᴅᴇ ZVÑIGA S.ᴛ ᴅGINES NACIO ENᴬᴮ ᴀᴵᴵᴅᴵͣ

The relationship between a rich patron and a chosen artist could be close and intensely personal. The patron was expecting the artist to confer immortality on him and his children, who were also his heirs. For the artist who could demonstrate that he could do this, great wealth could be his.

Titian received generous pensions from the Emperor Charles V, whose family he painted at the royal court in Augsburg. Rubens and van Dyck were both knighted by Charles I of England, who also gave them generous pensions and, in the case of van Dyck, two houses — one for summer and one for winter.

Royal patronage also increased an artist's standing with lesser patrons. When it was heard that Titian had been appointed official painter at the court of the Emperor Charles V in Augsburg, people flocked to Venice to buy up his paintings and to commission him to paint them and their families. 'There is hardly a noble of high rank, scarcely a prince or a lady of great name whose portrait has not been painted by Titian', noted Vasari.

Titian was also painting the children of these high-ranking people. His portrait of the 11-year-old Ranuccio Farnese, a grandson of the Farnese pope, Paul III, has been called one of the landmarks of the portrait form. For all his rich clothing and the gold cross on his cloak indicating that he holds the post of prior of the Church of St John of the Templars, Ranuccio Farnese is portrayed as a sensitive boy, a little ill-at-ease in his fine clothes.

In his superb group portrait of another Venetian dynasty, *The Vendramin Family* — or at least of its male members, for the family's six daughters were not included — Titian showed the same sensitivity towards childhood by putting a puppy into the arms of one of the youngest of the seven Vendramin sons.

In England, the work of the German painter Hans Holbein the Younger and, a century later, Anthony van Dyck, produced such powerful images of Henry VIII and Charles I that our perception of these monarchs is still shaped by them.

Among the paintings Holbein did for Henry VIII, which would influence the way the royal families of England and Scotland were portrayed for several generations, was one of his son and heir, Edward, who was probably less than two years old when the painting was done in 1538/9. *Edward, Prince of Wales* is enough of a true likeness of the child to show the apple cheeks and dimpled hands of a boy who has just left babyhood behind. But the overall effect of the portrait is something quite different: the richly-dressed child holding a gold toy is a study of royal power, a hieratic image of a prince who will be king, an effect enhanced by the child's right hand, held up as if in the act of blessing.

While Charles I believed firmly in the Divine Right of Kings, Anthony van Dyck did not use Holbein's hieratic approach

Opposite:
Francisco de Paula José de Goya y Lucientes (1746-1828) **Portrait of Manuel Osorio de Zúñiga** 1788; Oil on canvas; 50 x 40in. (127 x 101.6cm.) New York: Metropolitan Museum of Art, Jules Bache Collection. Goya's wonderful portraits of the children of the Spanish aristrocracy.

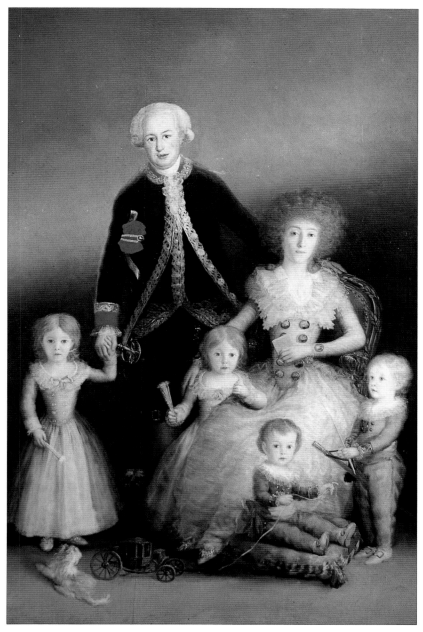

Previous page:
Francisco de Paula José de Goya y Lucientes (1746-1828) **The Duke and Duchess of Osuna and Their Children** 1790; Oil on canvas; 88 x 68ins. (224.4 x 173.4cm.) Madrid: The Prado. Although the aristocratic Osuna family was one of the most influential in Spain, Goya has painted their family portrait with simple directness and a great deal of charm. Both the duke and duchess are depicted as loving parents, rather than the leading members of fashionable society they were in reality, while the children pose quite naturally, without affectation.

Opposite:
Stephen Poyntz Denning (c.1795-1864) **Queen Victoria aged 4** 1823; Panel. London: Dulwich Picture Gallery. Princess Victoria, only child of the Duke and Duchess of Kent and, after 1821, the only surviving legitimate offspring of any of George III's sons, was an object of great public interest almost from the moment of her birth and, therefore, of considerable commercial value to painters and engravers. Unlike the daughters of George III, who were more often than not painted with romantic sweetness and delicacy, poor little Vicky seems almost swamped in her heavy, adult furs, feathers and velvet in this painting.

when portraying the king's children. Although he did not abandon the wonderfully rich tone and hues or the background marked by the panoply of royal power and wealth which were so effective in his portraits of Charles I, Queen Henrietta Maria and their courtiers, van Dyck adapted his use of them to suit his small and probably restless sitters. The children of Charles I and Henrietta Maria, as depicted by van Dyck, retain the artless innocence and simplicity of childhood in the midst of their rich surroundings.

The Spanish painter, Diego Rodriguez da Silva y Velázquez, painting the children of Philip IV in Spain at much the same time as van Dyck was working in England, used a similar approach.

In his many portraits of baby princes and childish infantas, all of them richly dressed in clothes embroidered in silver and gold and often accompanied by such essential marks of royal rank as dwarfs and large dogs, Velázquez always clearly portrayed the child at the heart of it all. In his paintings, baby curls flick out over lace collars, plump little hands clutch toy swords in a child-like way, infantas' faces, set between elaborately curled and beribboned hair, are innocently unshadowed by any thought of their royal destiny.

In Velázquez's enormously complex masterpiece, *Las Meninas* ('*The Maids*'), painted in 1656 near the end of his life, the face of the Infanta Margarita, perfectly emphasized by the artist's wonderful balance of light and shade, is that of a little girl, solemn-eyed and serious as she takes in her surroundings (which are not, in fact, the Alcazar Palace, but the artist's studio).

By the time Francisco Goya y Lucientes began painting a later generation of the Spanish royal family at the end of the 18th century, the traditional style of court painting was changing in Europe. This was particularly so in Britain during the long reign of George III, a model of domestic faithfulness and a man known affectionately to his subjects as 'Farmer George'. The royal children were painted much more informally than those of Charles I had been, Allan Ramsay and Thomas Gainsborough, in particular, producing many attractively relaxed and sensitive studies of the fourteen sons and daughters of King George and Queen Charlotte. Many of these studies of the children showed them dressed informally and with simple hairstyles because they were intended, not for public exhibition, but for hanging in the private apartments of the king and queen.

Goya's work in Spain was even less marked by any feeling that his royal sitters need be made larger than life. The vigorous realism and humanity of Goya's treatment of the court of Charles IV in Madrid, untainted by any idea of flattering his royal patron and his many relatives, resulted in some very fine studies of the children of the royal family.

Among Goya's numerous paintings of his royal patron, the Duke of Osuna, one, *The Duke and Duchess of Osuna and Their Children*, is hardly a 'court' painting at all, for there is no richly furnished background, nor are there servants, dwarfs or great hounds. Rather, we are given a delightful glimpse into the private life of a happy family. The duke, far from striking a regal pose, stands with one hand on the back of his wife's chair while the other holds his daughter's hand. Another little girl leans against her mother's knee while two small boys play at her feet. Scattered round them are toys and two small, hairy dogs.

In taking the mystique out of royalty, Goya was helping to deal a death blow to court painting as it had been practised for several centuries. The most richly portrayed court in 19th-century Europe, in terms of quantity as well as quality, was that of Queen Victoria and Prince Albert in Britain. Despite the many grand portraits of the royal family produced by artists like Frans Xaver Winterhalter and Sir Edwin Landseer, the overall impression left by the court art of the period before Prince Albert's untimely death, including the watercolors and drawings of the monarch, herself a talented amateur artist, is of a lively young family, their lives revolving round the routine of the nursery and of family life.

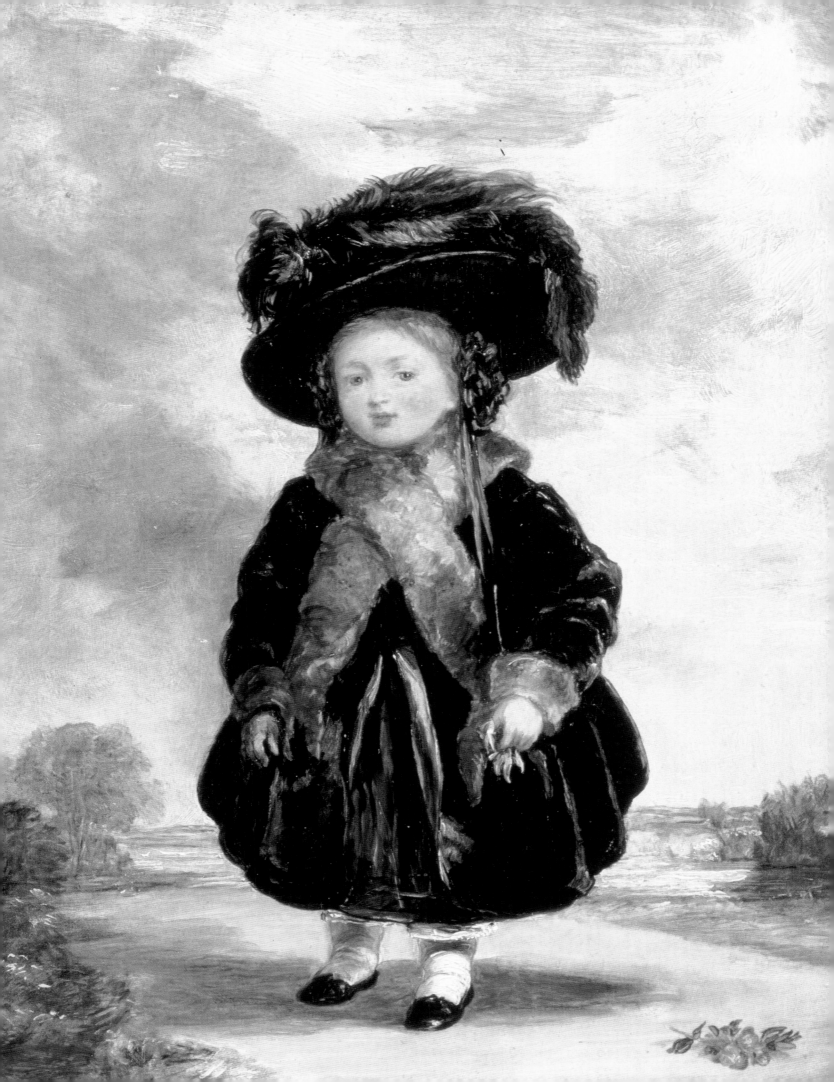

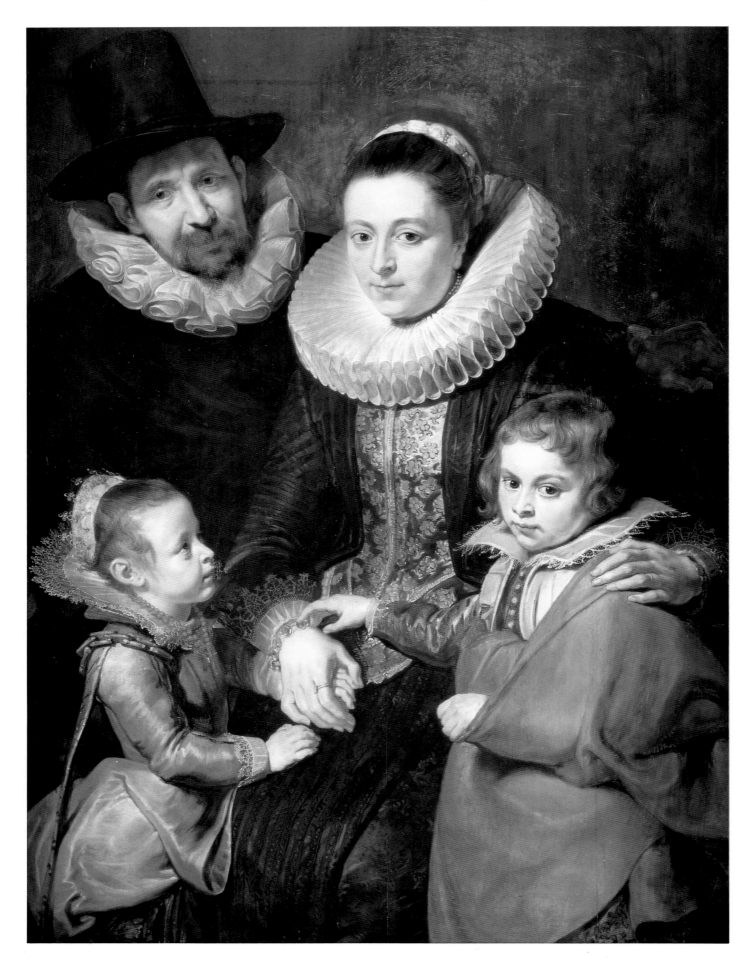

FAMILY GROUPS

The family group, an important theme in religious art, was soon taken up in secular painting. Even among paintings done mainly to promote the image of the great Italian dynasties were many where the depiction of family relationships were to the fore: Pedro Berruguete, commissioned to paint Federigo da Montefeltro in such a way as to emphasise the duke's great library in his palace at Urbino, chose to portray the duke reading to his small son from one of the volumes in his library.

During the Tudor and early Stuart periods in England, among the many formal portraits of the rich and the great in the land, were to be found a wide array of pictures of families, not in the grand poses and rich costumes of court paintings, but set amidst domestic surroundings. Often, these pictures would have been done by itinerant 'limners' or by painters who had done most of their work far from the capital and were therefore unfamiliar with current fashion or, sometimes, by refugee Protestant painters seeking safety in England from religious persecution in the Netherlands.

In the rich art collection at Longleat House in Wiltshire is a splendid family group by an unknown artist, *William Brooke, 10th Lord Cobham and His Family*, painted in 1567, in the second decade of Elizabeth I's reign. The three richly dressed adults and six children in the painting are shown seated round a table set with a fine display of fruit, and a live parrot. Another bird sits on the wrist of one of the boys, a puppy jumps on the knee of another, while the baby of the picture clutches an apple. Despite its stiffly linear treatment of the family, the richly detailed painting is full of vigorous life.

That artists from the Netherlands were working in England in Elizabeth's reign is significant for, where 'court' portraiture grew out of the Italian Renaissance narrative style of painting, with its heroic, monumental approach, 'family' portraiture was very much a part of the Northern European, Netherlands tradition.

In the Netherlands in the 15th century, art, even when the subject was religious, was based on a close observation of nature and the details of everyday life. The artists of the Netherlands also developed a very strong sense of the parts to be played by space and light in a picture.

Pieter Bruegel, working in the mid-16th century, made great use of these characteristics of Netherlands art throughout his work. He also added a strong note of morality, both in his paintings of religious subjects, set in vast landscapes, and in his wonderfully observed scenes of peasant life, with their satirical comments on such common evils as gluttony, drunkenness and lust. Bruegel bequeathed to later generations of artists, both in the Netherlands and

Opposite:
Peter Paul Rubens (1577-1640)
The Family of Jan Bruegel the Elder 1613-15; Oil on panel; 49¾ x 37⅞in. (124.25 x 94.6cm.) London: Courtauld Institute Galleries. In this beautifully composed picture Rubens has used the arms and hands of his sitters to link them together in close and informal harmony. The family is Ruben's close friend and artistic collaborator, Jan Bruegel, his wife Catharina van Marienberg and their two eldest children, Elizabeth and Peter.

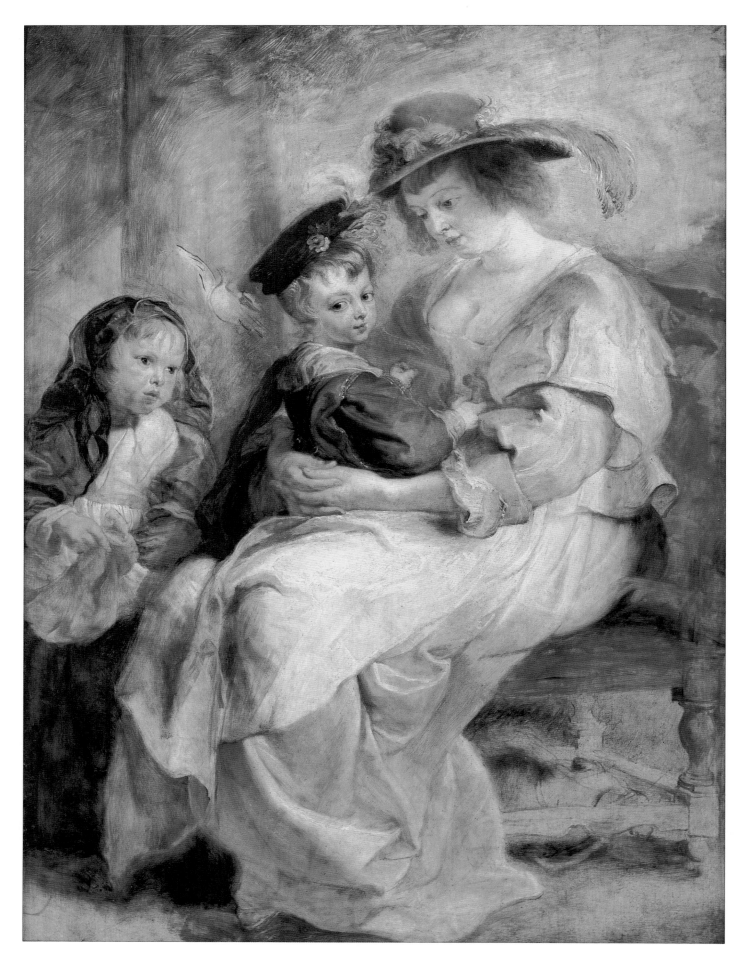

in Holland (the Protestant northern provinces of the Netherlands which achieved independence from Spain in the late 16th century), his deep feeling for nature and his belief that man was at his best when he was at one with his surroundings — ideas which were to have an important effect on the way in which family life was depicted in painting.

They show, for instance, in Peter Paul Rubens' painting of Pieter Bruegel's younger son, Jan and his family, *The Family of Jan Bruegel the Elder*. The picture shows Jan Bruegel, his wife, Catharina, and their two eldest children, a boy and a girl, grouped closely together in an intimate and informal style. Catharina is set at the centre of the group, indicating her central role as wife and mother. Jan Bruegel, slightly behind the other three, has his left arm stretched wide behind his wife's shoulder, as if embracing his whole family. The family is richly, though simply dressed, there is no background detail and no indication that Jan Bruegel is an artist. Everything is concentrated on the four people, bound together by family love.

Rubens conveyed the same impression of a loving, close-knit family in the numerous paintings he did of his second wife, Hélène Fourment, and their children. In a particularly attractive painting, *Hélène Fourment and Two of her Children*, Rubens, in recording a happy moment when young Frans and Clara Joanna are listening to their mother, also made a loving evocation of motherhood.

Frans Hals, like Rubens, came from an Antwerp family, but spent most of his life in Haarlem, in Holland. He was thus at the centre of the enormous flowering of the arts which Holland knew after shaking off Spanish rule. The world of the Dutch artist in the 17th century, far removed from the glories of the Italian Renaissance and set in a Protestant environment, offered little patronage for religious or decorative painting. Thus Dutch artists developed the 'genre' type of picture with its emphasis on everyday life and surroundings and made two great themes, landscapes and the group portrait, their own.

Frans Hals who, with Rembrandt van Rijn, was one of the greatest exponents of the Dutch group portrait, was also a superb genre painter. In his painting *Family Group in a Landscape*, Hals used his great skills as a portrait painter in a more natural, informal way than was the custom of the time (the late 1640s) to introduce a note of greater directness into the portrayal of ordinary people. The family he depicts ranges from a baby in arms to an elderly grandmother, tenderly holding the hand of one of her lively little granddaughters. The face of each person is clearly delineated but, in the great tradition of the Dutch group portrait, the effect is not just of a collection of portraits, but of a group of people interacting with each other.

Among other masters of genre painting in Holland at this time, Pieter de Hooch was famous for his light-filled scenes set in exquisitely detailed domestic interiors, where two or three figures would be engaged in some household task. Often, there would be a child in the picture, perhaps helping in the house, or a mother might be depicted tenderly feeding her baby, as in *Young Mother*.

Nicholas Maes, a pupil of Rembrandt, also painted small domestic interiors with a certain formal elegance. In paintings with titles like *A Woman Scraping Parsnips, with a Child Standing By Her* Maes worked in much the same style as de Hooch. More exuberant and lively, and often touched with humour or satire, was the work of two Leiden-born artists, Jan Steen and Gabriel Metsu. Steen, in particular, was very prolific, producing large numbers of genre scenes involving lively crowds of people or set in clearly ramshackle households with the various members of the family, children included, taking part in the scene. So disorganized are the jolly, noisy family portrayed in Steen's *The Merry Family*, where the setting of food on the table seems to be the signal for every-

Oposite:
Peter Paul Rubens (1577-1640) **Hélène Fourment and Two of Her Children** *c.*1635; Oil on panel; 441/2 x 321/4in. (17.8 x 12.9cm.) Paris: Louvre. Rubens was blissfully happy in his second marriage to the young and lovely Hélène Fourment, who bore him five children. The artist expressed his love for his family in many portraits and drawings of them, of which this unfinished oil painting, with its tender evocation of the joy of motherhood, is one of the most moving.

Pieter de Hooch (1629-84)
Young Mother *c.*1658-60; Oil on
canvas; 265/8 x 2113/16in.
(65.5 x 53.6cm.) The Fine Arts
Museums of San Francisco: M.
H. de Young Memorial Museum,
Gift of the Samuel H. Kress
Foundation. The Dutch artist
Pieter de Hooch's wonderfully
sensitive feeling for the play of
light on a painting gave his deli-
cately observed domestic scenes a
poetic intimacy. This quiet study
of a woman feeding her baby
while an older child plays with a
dog is a particularly fine example
of his work.

Overleaf:
Jan Steen (1625/6-79) **The
Effects of Intemperance** *c.*1663-5;
Oil on panel; 303/8 x 423/8 in.
(76 x 106cm.) London: National
Gallery. Although Steen, one of
many Catholic artists working in
Protestant Holland, painted real-
istically and with a lightness of
touch, there was often a clear
moral message in his pictures
which could easily be understood
by his contemporaries. Thus, this
painting of a family group in
trouble warns of the evils of a
mother's drinking so much that
she cannot teach her children
virtue, keep a careful eye on her
servants (or, indeed, her husband,
to judge by the man flirting with
the buxom wench in the back-
ground), or run a frugal, well-
organized household.

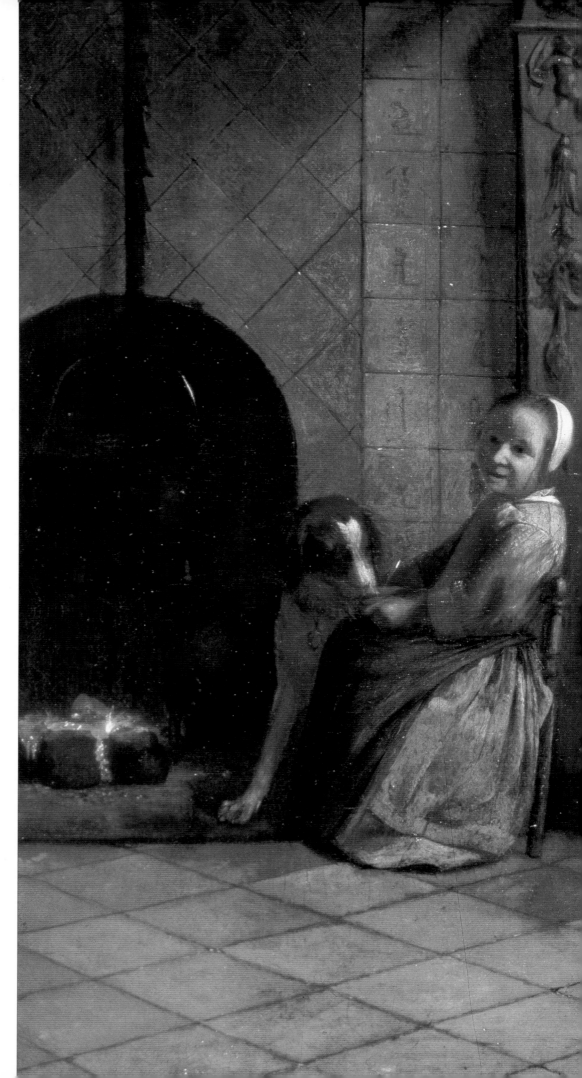

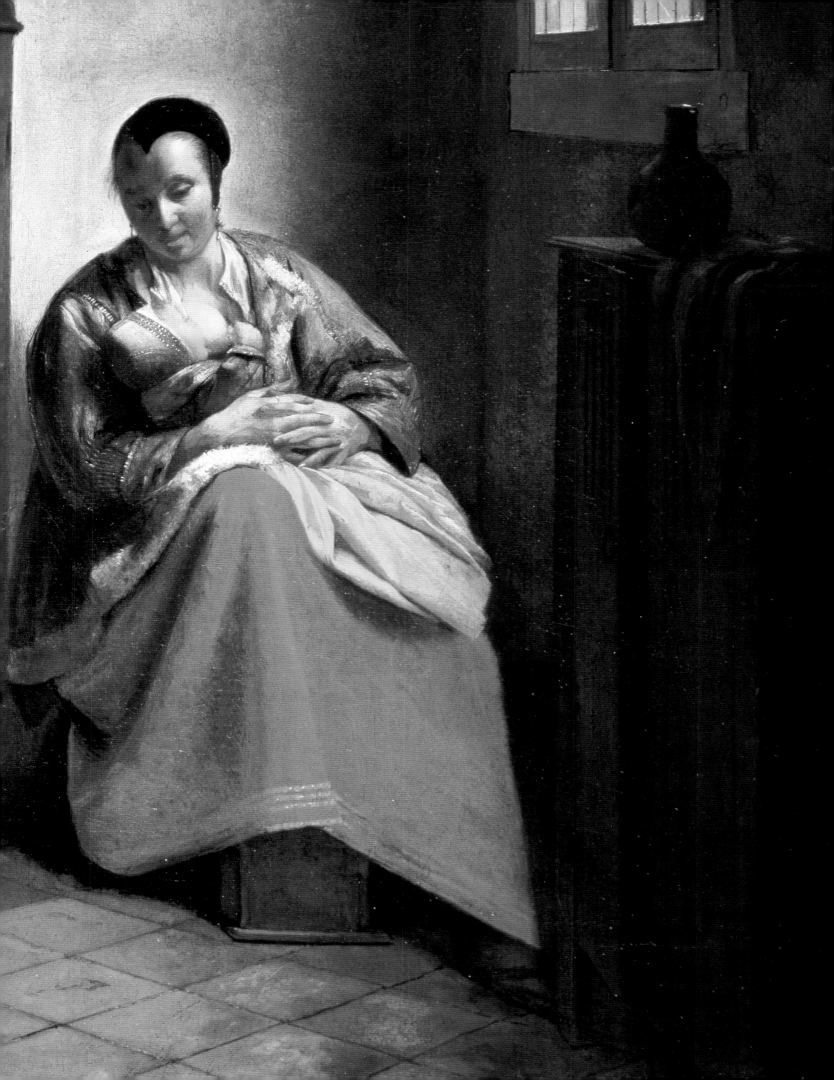

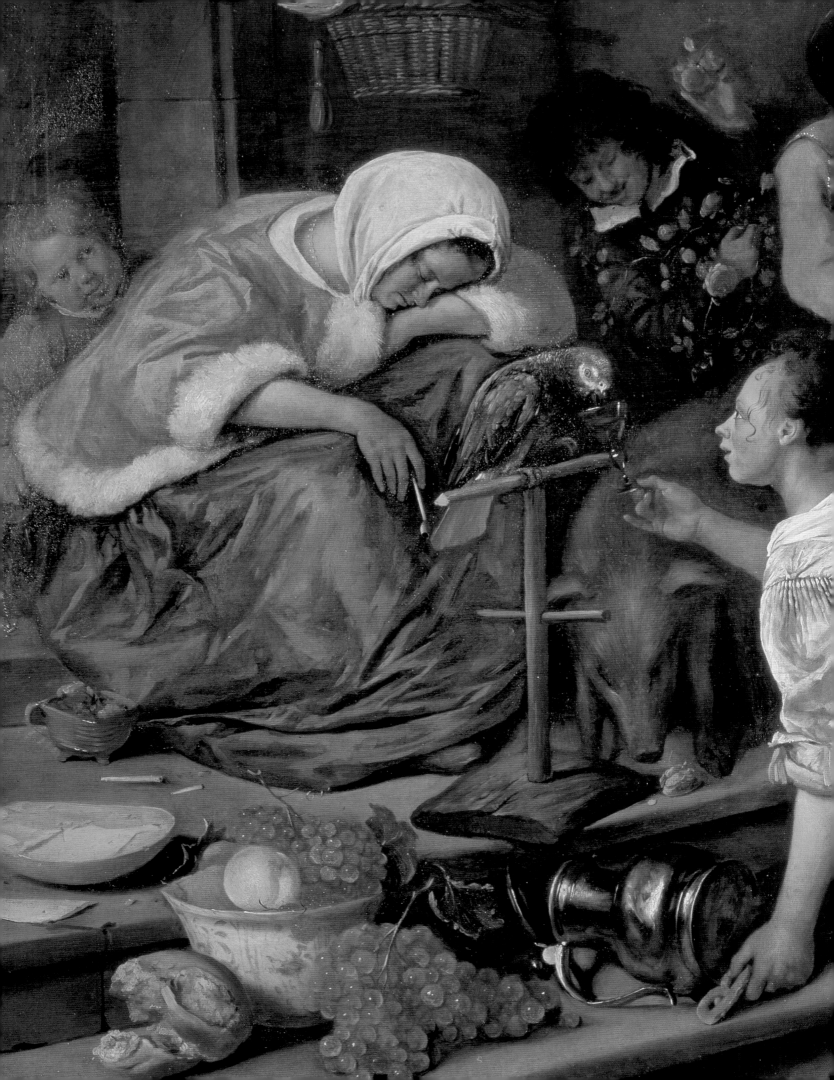

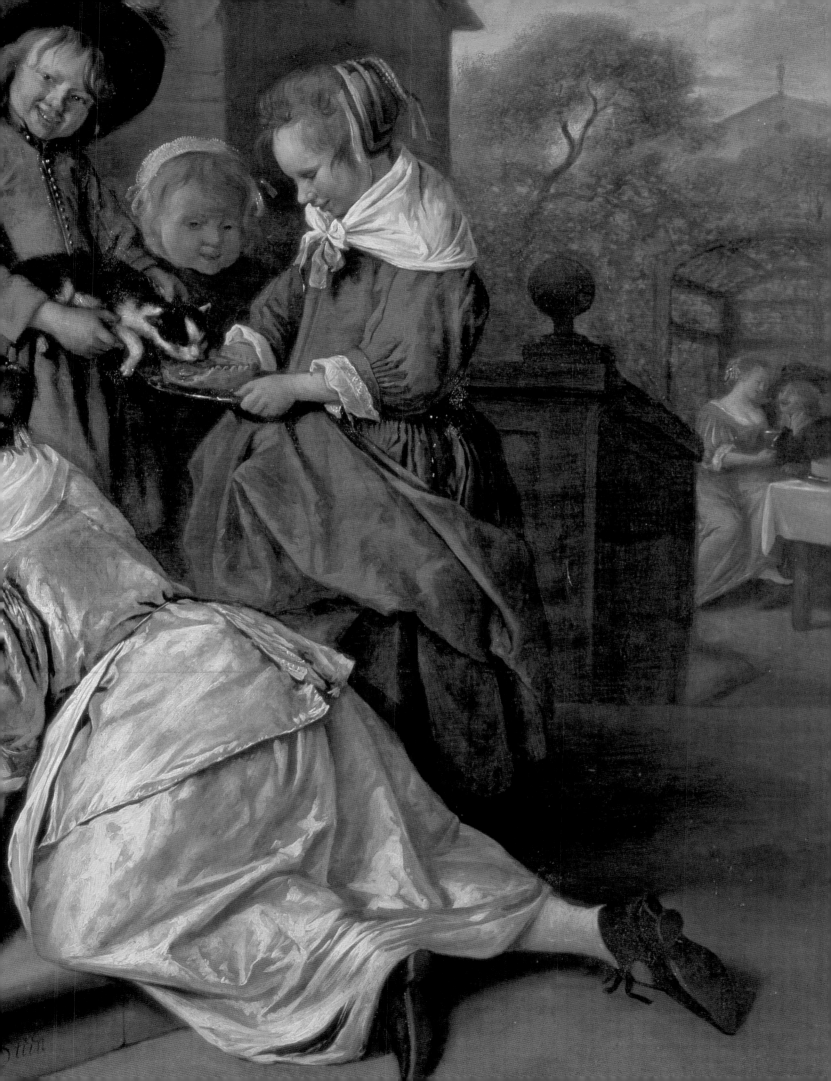

one to start playing his own musical instrument or to sing a song, that the youngest members of the family have already learned to help themselves rather than wait to be fed.

Many Dutch and Netherlands artists worked in England in the 17th century, attracted there first by Charles I's great interest in art, which he had demonstrated from early childhood, and then by the presence of Rubens and van Dyck in London. Cornelius Johnson, born in London to parents who had fled religious persecution in Antwerp, was best-known for his portraits, so it is not surprising that his attractive *The Family of Arthur, Lord Capel*, works best as a collection of individual portraits rather than a group picture.

Showing less of the influence of the Dutch tradition is a family group called *The Saltonstall Family*, attributed to David des Granges. This painting, which is in the collection of the family of the art historian Kenneth Clark, was described by Oliver Miller, when he was Surveyor of the Queen's Pictures, as 'perhaps the most distinguished and charming work of its kind painted in England in the Stuart period'.

The subject could not be more intimately domestic: Sir Richard Saltonstall

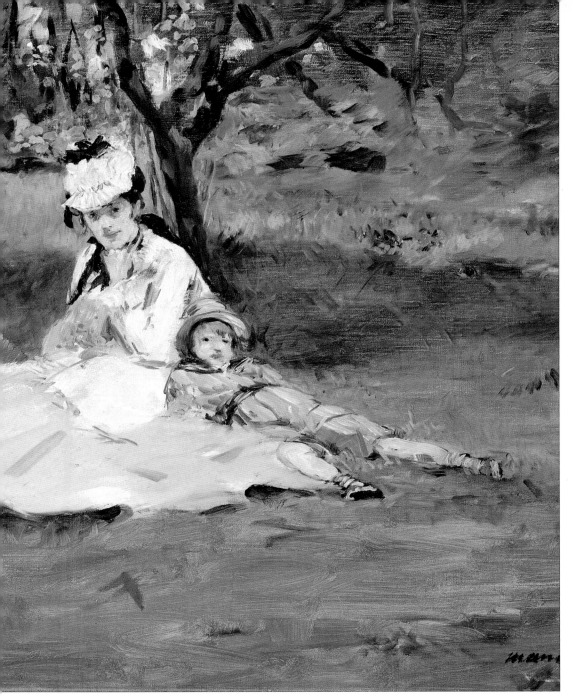

Left:
Edouard Manet (1832-83) **The Monet Family in the Garden** 1874; Oil on canvas; 24 x 39 1/4in. (61 x 99.7cm.). New York: Metropolitan Museum of Art, bequest of J. Whitney Payson. Seduced by the light and the colours in Claude Monet's garden at Argenteuil, Edouard Manet painted this delightful, typically Impressionist picture of Monet, his wife Camille and their elder son, Jean, in one summer afternoon. Camille, chin in hand and with Jean leaning against her, is also the subject of a painting by Pierre Auguste Renoir because Renoir came visiting on that same lovely afternoon, borrowed canvas, brushes and paint from Monet and enthusiastically went to work beside Manet.

stands by the bedside of his wife, who has just given birth to their third child (already wrapped in swaddling clothes and in the arms of nurse by the bed); Sir Richard holds the hand of his small son Richard who, in turn, holds his sister's hand.

The Saltonstall Family is an excellent signpost to the direction the portrayal of the family has taken in European art. Lively, realistic and even bawdy in the conversation pieces of William Hogarth, the portrayal of later 18th century families, even upper class ones, became much more intimate, with the people being portrayed showing real feelings.

This was particularly so in those paintings which exalted maternity, an increasingly fashionable theme at a time when the Romantic movement was getting into its stride. Sir Joshua Reynolds' *Lady Cockburn and Her Three Eldest Sons*, painted in 1773, showed the mother looking tenderly at her son, while the two elder boys look charmingly mischievous.

While a fine portrayal of family love, there is more than a hint in Reynolds' work of the way in which much of the portrayal of the family in 19th-century European art would take on a sickly sentimentality, particularly in popular art,

Pierre Auguste Renoir (1841-1919) **Madame Charpentier and her Children** 1878; Oil on canvas; 601/2 x 747/8 in. (153.7 x 190.2cm.) New York: Metropolitan Museum of Art, Wolfe Fund. Georges Charpentier, publisher of the influential journal *La Vie Moderne*, commissioned several portraits of his family from Renoir, including this superb portrait of Marguerite, M. Charpentier's wife, and their two children, Georgette and Paul, beautifully grouped in a fashionable interior. It was Renoir's first big public success, attracting considerable attention when it was exhibited at the Paris Salon in 1879, the year in which Renoir also had a successful one-man exhibition at the Paris gallery associated with *La Vie Moderne*.

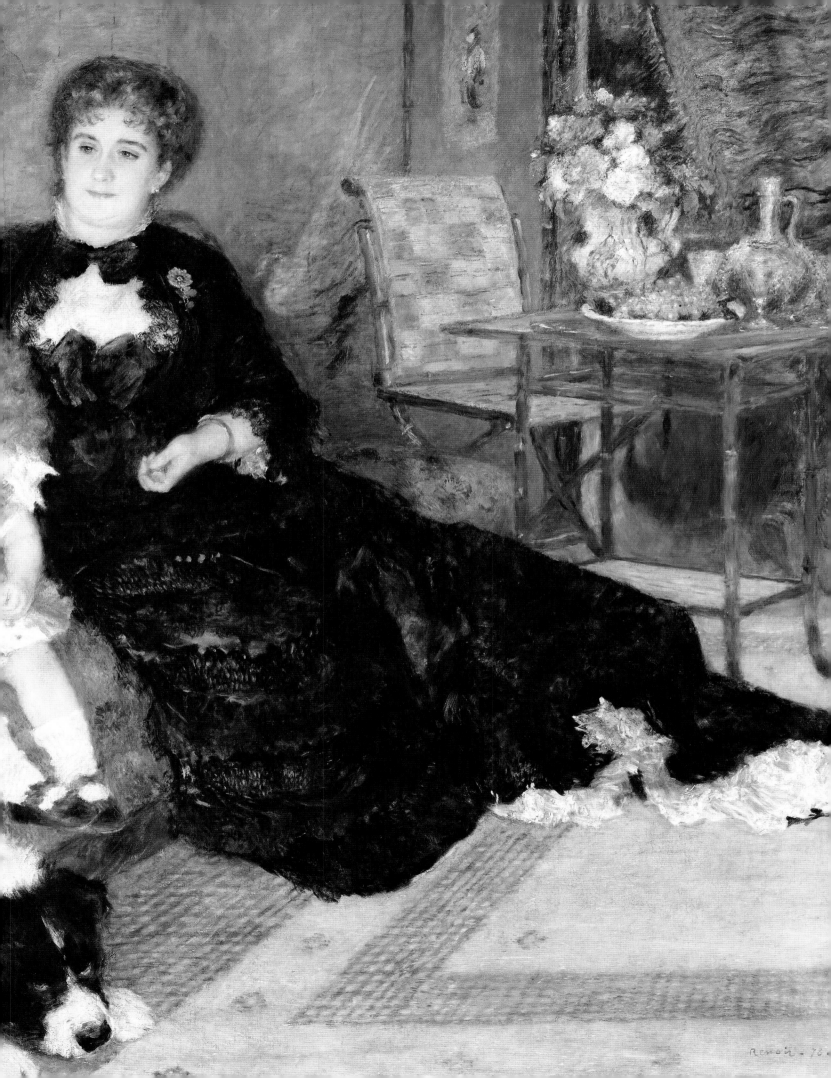

much of which ended up on cards, postcards and in prints.

The Impressionist painters and their associates, by letting the light of reality, either indoors or outside, into the family portrait, did most to rescue it from this sentiment. While Pierre Auguste Renoir's *Madame Charpentier and Her Children* is clearly a more formal work, having been commissioned by M. Charpentier, than Edouard Manet's delightfully spontaneous *The Monet Family in the Garden*, both paintings share an approach to their subject which combines an informally intimate style with a lightly relaxed technique; adults and children alike are painted with a gentle charm that has nothing to do with cloying sweetness.

Mary Cassatt, who spent much of her artistic life exploring and overcoming the problems of portraying children, particularly within the 'mother and child' theme, was not concerned solely with portraits. She produced many fine pictures of family life which, although they depended on using the members of her family as models, were not intended simply as group portraits.

For Cassatt, creating an atmosphere of spontaneous informality within a narrative treatment of her chosen subject was more important than producing realistic portraits of her family. *Mrs Cassatt Reading to Her Children*, for instance, was to Cassatt a saleable picture, not a group portrait of her mother reading to her grandchildren Katherine, Rob and Elsie. Her family thought otherwise; after all, Mrs Cassatt thought, Mary could hardly sell her mother and nieces and nephew. When Mary, the artist, did just that, Mary, the daughter, was pressured into buying it back to give to her brother Alexander, father of the children in the picture.

Mary Cassatt's difficulties here arose from the fact that she was a woman and an American at a time when American society had not yet learned to take art or the female artist seriously: on her first visit home after having made a place for herself in European art, Mary Cassatt found herself being referred to in a newspaper as a 'sister of Mr Cassatt, president of the Pennsylvania Railroad... She has been studying painting in France and owns the smallest Pekingese dog in the world.'

Today, the United States' finest museums and galleries are proud to number Mary Cassatt's paintings of children and family life in their collections.

Opposite:
Claude Oscar Monet (1840-1926) **Camille et Jean** 1873; Oil on canvas. Private collection. Social comment and even subject matter were of less concern to Monet than the depiction of the effects of light and colour. Unlike Renoir, for instance, Monet seldom produced finished portraits of his family, choosing instead to make them the focus of attention in many paintings set outdoors, either in the gardens of his various houses or in nearby countryside. Monet's beautiful wife, Camille, was an essential part of many of his finest paintings in the 1860s and 1870s (she died tragically young in 1879), while their elder son, Jean and his sailor suit also featured in numerous paintings of the early 1870s.

Augustus John (1878-1961)
David and Dorelia in Normandy
Oil on canvas. Cambridge: Fitzwilliam Museum. This picture of Augustus John's second wife, Dorelia, and their son David enjoying the pleasures of summer on the breezy, sunny northern coast of France is typical of the strong colour and relaxed, semi-Impressionist, handling of paint, set on a foundation of solid draughtmanship, which marked much of John's work.

Claude Oscar Monet (1840-1926) **Camille Monet and a Child in the Artist's Garden in Argenteuil** 1875; Oil on canvas; 21 3/4 x 25 1/2 in. (55.3 x 64.7cm.) Boston: Museum of Fine Arts, anonymous gift in memory of Mr and Mrs Edwin S. Webster. A flower border in Monet's garden at Argenteuil makes a colourful backdrop for this charming domstic scene, in which Camille Monet sits quietly sewing while a friend's child sits at her feet playing with a small wooden horse. Monet has allowed no hint of the realities of modern life at Argenteuil, a suburb of Paris just a short train ride from the centre of the city, to intrude into his country scene.

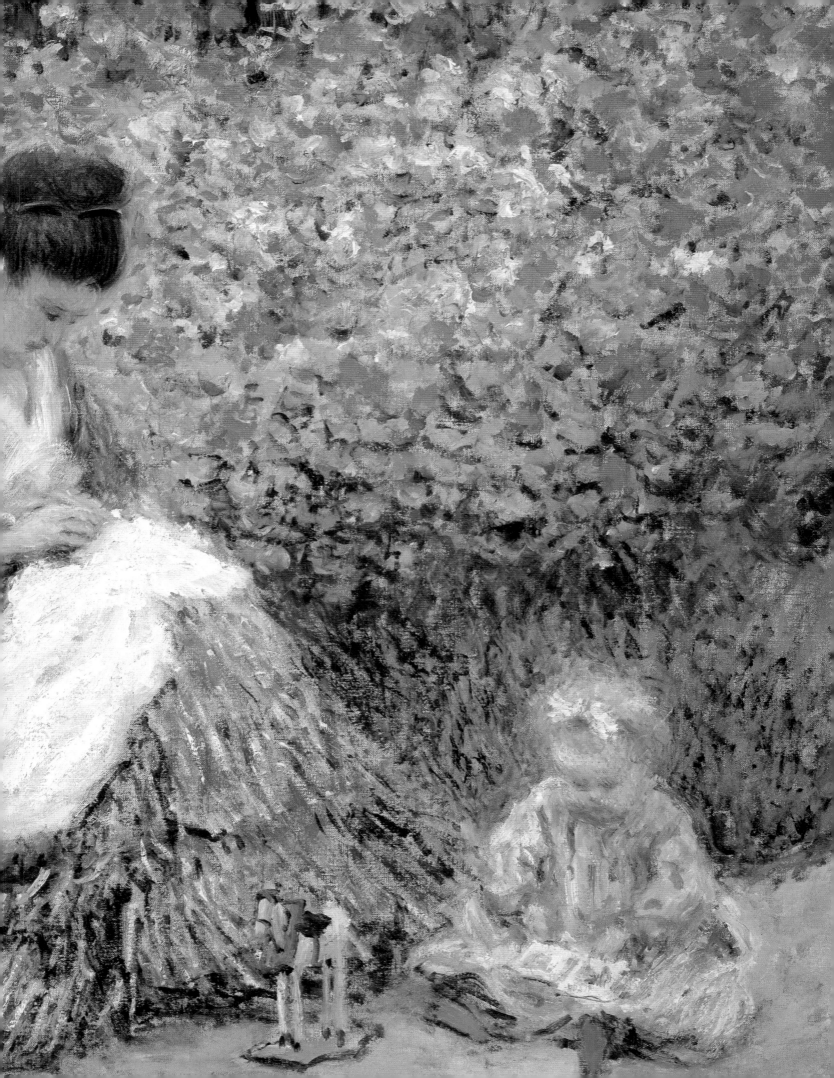

\mathscr{C} HILD \mathscr{S} TUDIES

\mathscr{A} n artist painting a child who is not his own must begin by treating the infant or young person as a subject of study, divorced to a greater extent than with an adult sitter from the usual requirements of the commissioned portrait. Paintings of adults are inevitably constrained by the requirements of the sitter's status in society: monarchs expect to look regal, great lords must exude power and nobility and even the affluent middle classes want their portraits to convey their social position.

With children, unless he is painting the heirs of kings, the artist usually has greater freedom, for the commissioning parent is generally quite content if the child in the finished picture, as well as being recognizably his son or daughter, looks lively, happy and intelligent. This enables the artist to concentrate on the child as a young human being and to search in his or her features for signs of the character which will emerge in the adult as well as to portray the charm of youthful exuberance or, in contrast, the cares and complexities of youth.

For the artist, the main interest in portraying youth lies in the implications of young life: a world of its own which an adult cannot entirely penetrate, even though he has experienced it himself and is now its overseer. If he can paint the child simply, without moral overtones, so much the better; the portrait will be all the more true as a study of the child.

Inevitably, both in studying and attempting to comprehend the sitter's character and in deciding on such basics as pose and background, the artist's own personality often obtrudes, imposing an adult interpretation on the scene, though how far it does so depends on the artist's own sensibility and objectivity. Some artists are content to portray the child, others need to give their picture a theme, even if it is as simple as the innocence of childhood or, more seriously, the vulnerability of childhood and even of the whole of human life. Children blowing bubbles, a recurring image in European art, was, in fact, a traditional symbol for the transience of human life, summed up in the classic adage, *homo bulla*: 'man is a bubble'.

As early as the beginning of the 17th century, artists, particularly those working in the Dutch and Flemish traditions, were able to look at and record children as real people. Even an obscure artist like Jacob van Oost, about whom little is known beyond the fact that he worked in Bruges, could produce in *Portrait of a Boy Aged 11* a sensitive character study outstanding for its finely muted tone.

Judith Leyster, like her artist husband Jan Molenaer, was born in Haarlem, where she may have studied in Frans Hals' workshop for a time, and was a prolific painter of genre scenes, especially of groups of people laughing and

Opposite:
Jacob van Oost the Elder (1601-71) **Portrait of a Boy aged 11** Oil on canvas. London: National Gallery. This sensitive study of a young boy is a particularly fine example of the Flemish artist Jacob van Oost who worked in Bruges, doing mostly portraits and figure painting.

Overleaf left:
Rembrandt van Rijn (1606-69) **Portrait of a Boy (The Artist's Son, Titus)** *c.*1645-50; Oil on canvas; 251/2 x 22in. (65 x 56.1 cm.). Los Angeles: Norton Simon Foundation Collection. Rembrandt painted numerous wonderfully sensitive paintings of the members of his family, those of his eldest son, Titus, being among the finest.

Overleaf right:
Joan van Noort (*c.*1620-after 1676) **A Boy with a Hawk and Leash** *c.*1660s; Oil on canvas; 331/4 x 263/4 in. (83.2 x 67cm.). London: Wallace Collection. Born in Amsterdam and influenced by Rembrandt, van Noort painted portraits, genre subjects and history pictures. This attractive painting is one of two studies by van Noort of a boy with a hawk in the Wallace Collection.

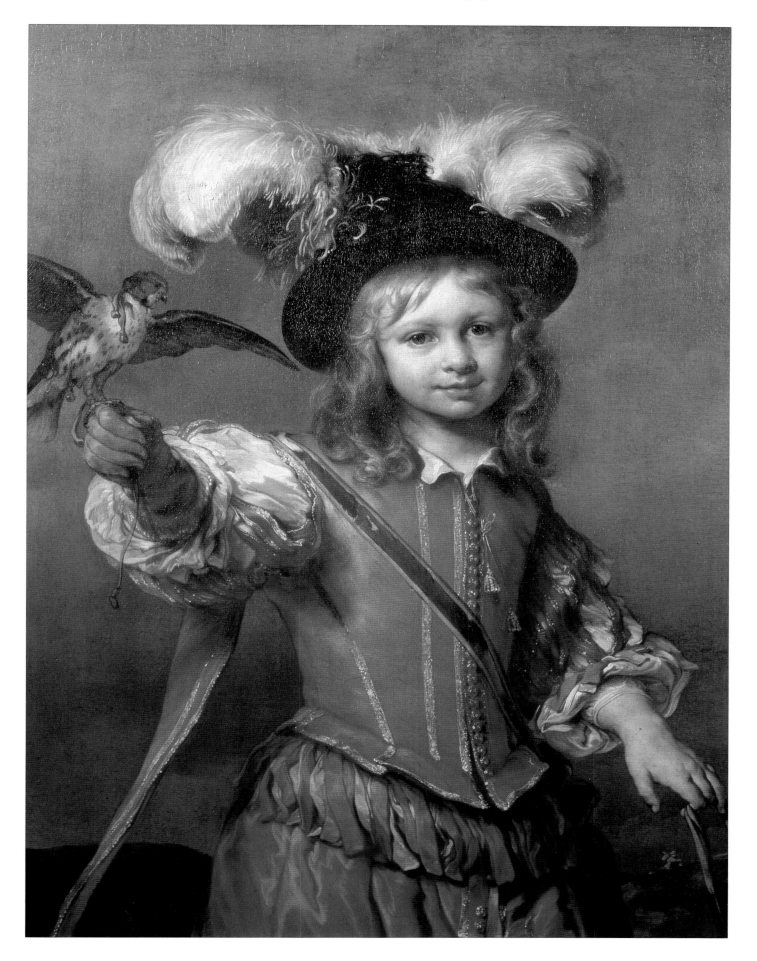

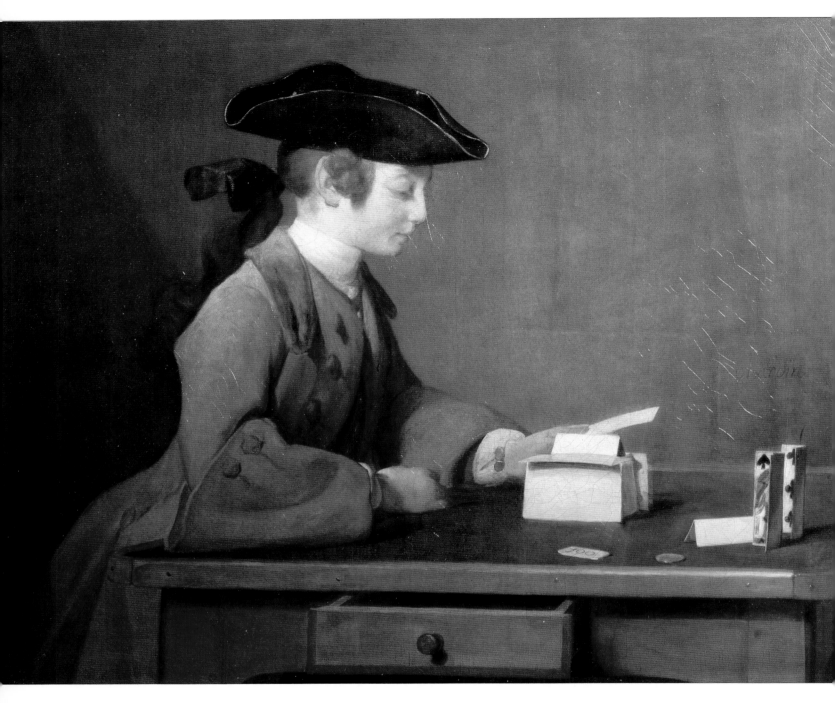

Jean-Baptiste Siméon Chardin (1699-1779) **The House of Cards** c.1736-7; Oil on canvas; 24 x 284/5in. (60 x 72cm.). London: National Gallery. A superb still-life painter early in his career, Chardin was sufficiently influenced by the Dutch and Flemish schools of domestic and everyday life painting to turn to figure painting, producing some fine works, including this study of the son of his friend, Lenoir, a cabinet-maker.

drinking together in an easy-going style free from social attitudes. Among her best-known works is *A Boy and a Girl with a Cat and an Eel*, in which two children laugh unselfconsciously at people outside the frame of the painting. It is a delightful study of children, concentrating on the freedom from care felt by most children.

It is not easy, of course, to persuade young children to pose for the lengthy sittings required by artists intent on producing formal studies rather than quick sketches. Many paintings of children are the result of studies done at appropriate moments over long periods of time. Since this is something that is only possible when the artist has the opportunity to see his subject frequently, many of the best child studies have been based on the artist's own children. Among Rembrandt van Rijn's fine studies of children, one of the most famous, *Portrait of a Boy*, was long called *Portrait of the Artist's Son Titus*, partly because it was felt that the perfect intimacy of the portrait was, surely, some-

58

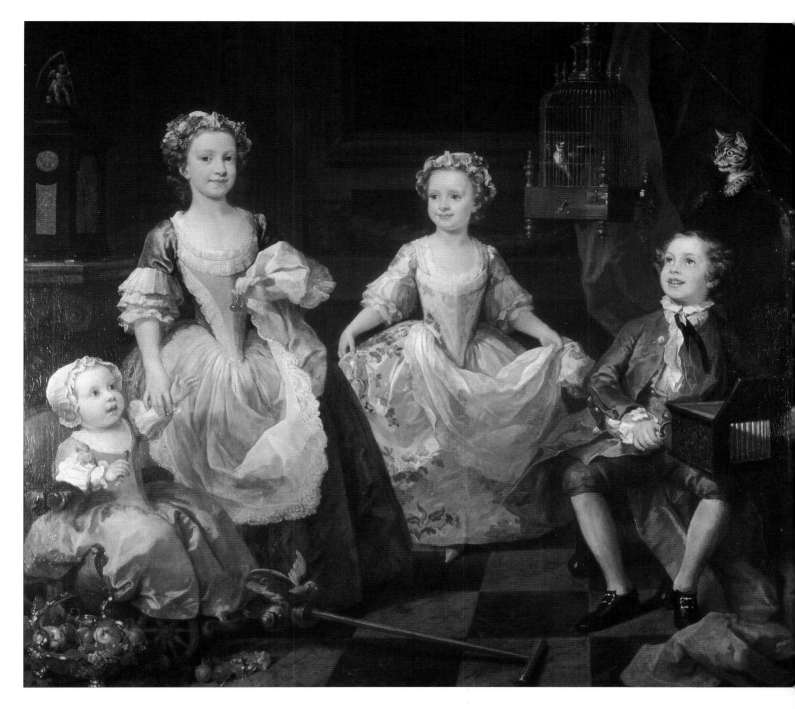

thing that only a father drawing his own child could achieve. Recent research has indicated, however, that when the picture was painted, Rembrandt's son Titus was older than the boy in the painting.

For artists living in countries where climate and custom allow much ordinary life to go in the streets of towns and villages, achieving familiarity with the actions of people, adults and children, is not difficult. The Spanish artist Bartolomé Esteban Murillo spent most of his life in the large and busy city of Seville, with its crowded streets, squares and market places.

Famed in his early career for his delicately observed religious scenes, especially the Holy Family, and for his tender, lovely Virgins, Murillo became a brilliant portraitist and also a fine painter of genre subjects, putting on canvas the scenes of everyday life he saw around him in Seville. A favourite Murillo theme was the street urchin or beggar boy, picturesquely painted in rags unsullied by street dirt and untouched by poverty. Such pictures found a ready mar-

William Hogarth (1697-1764) **The Graham Children** 1742; Oil on canvas; 63 1/4 x 71 1/4 in. (158.1 x 178.1cm.) London: National Gallery. More than a charming study of childhood, Hogarth's picture of the four children of Daniel Graham, Apothecary to Chelsea Hospital in London, is also an allegory on the inevitable ending of childish innocence: the Cupid on the clock holds a scythe, suggesting the passing of time.

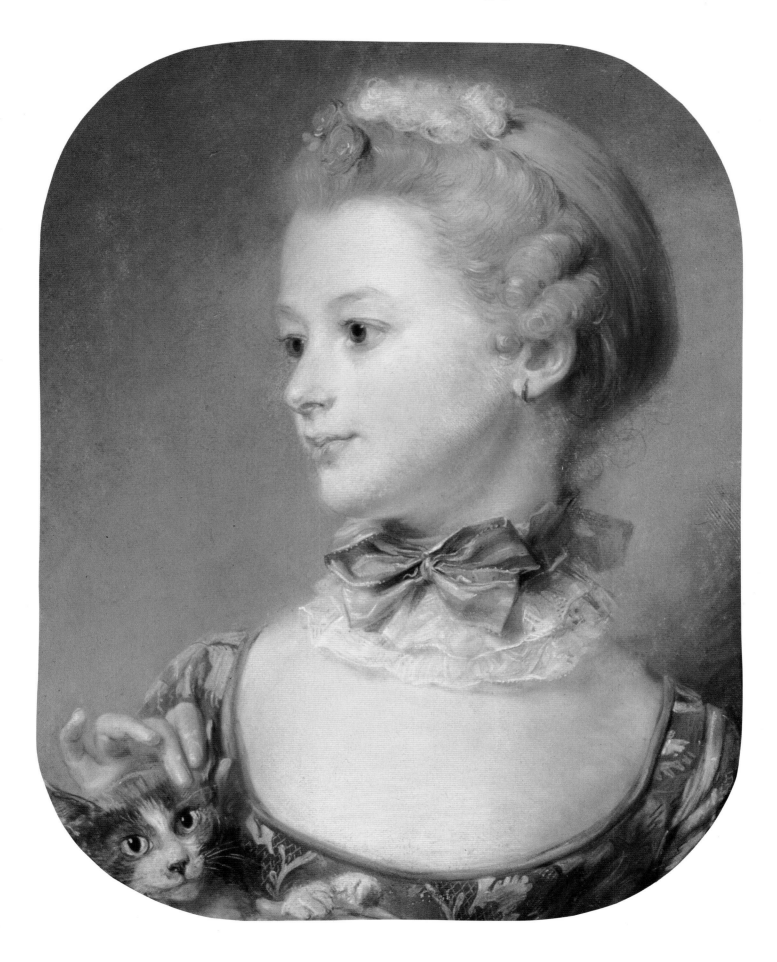

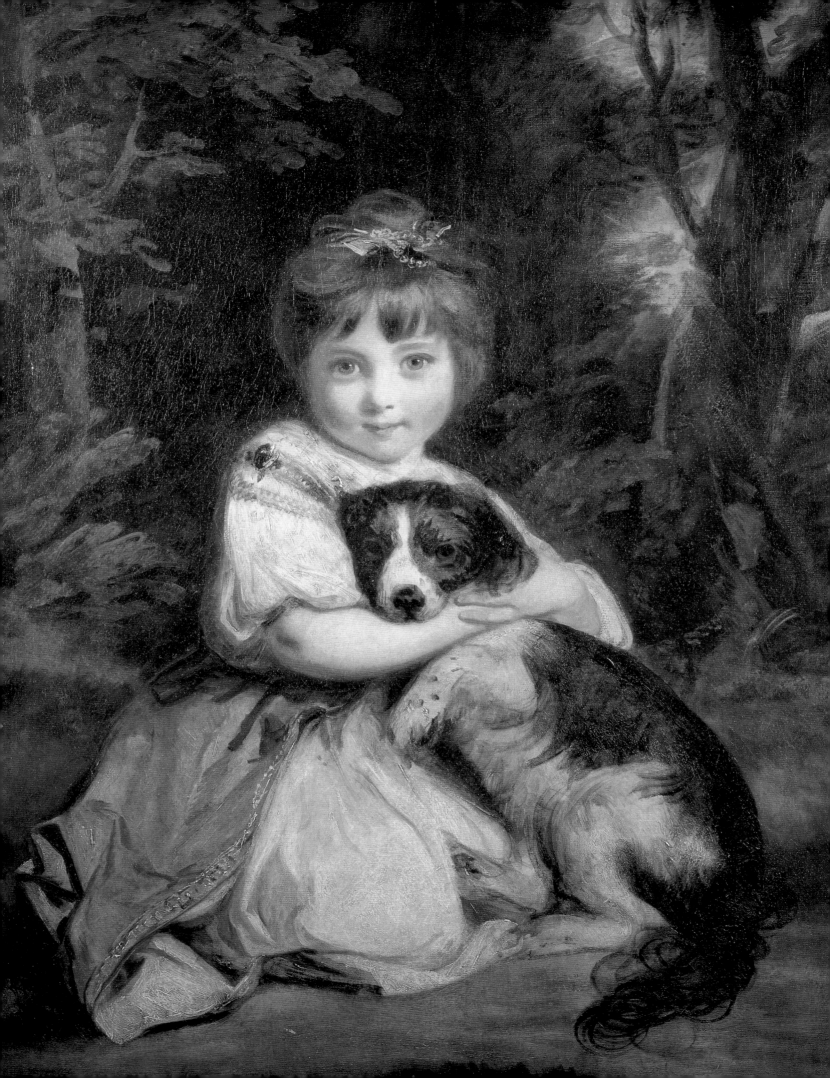

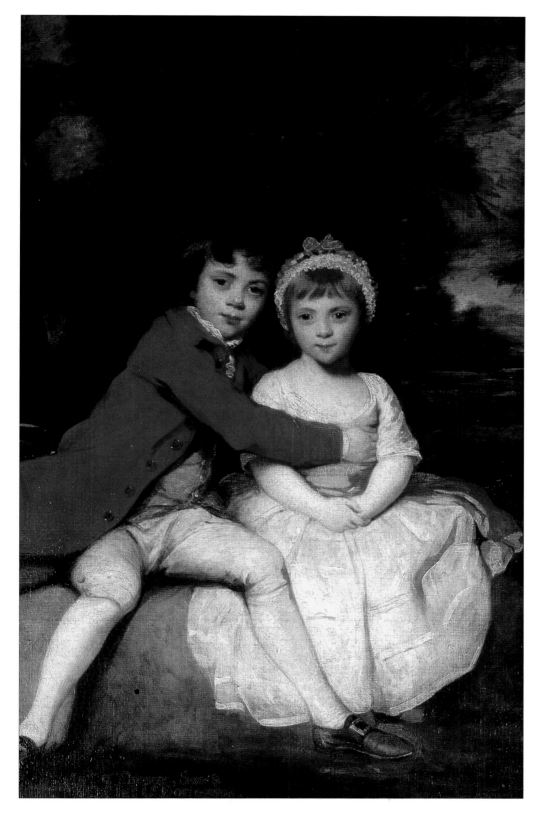

Previous page left:
Jean-Baptiste Greuze (1725-1805)
Boy with a Lesson Book
Oil on canvas; 24 1/2 x 19 1/4in.
(62.5 x 46cm.) Edinburgh:
National Gallery of Scotland.
This picture of a boy studying, is
a particularly fine portrait by
Greuze, a French artist whose
career, based very much on
depicting the frivolities and
sentimentalities of the end of the
ancien régime, was ruined by the
Revolution.

Previous page right:
Jean-Baptiste Perroneau (1715-
83) **Girl with a Cat (Portrait of
Mlle. Huquier)** 1747; Pastel;
181/2 x 15in. (47 x 38.25cm.)
Paris: Louvre. Perroneau's artistic
contemporaries, such as Boucher
and Lepicié, sometimes included
cats as subtle symbols of
eroticism in paintings of women
at their toilette.

Left:
Joshua Reynolds (1723-92)
**Master Parker and his Sister,
Theresa** 1779; Oil on canvas;
555/8 x 431/2in (142 x 111cm.).
The National Trust: Saltram,
Devon. Seven-year-old John
Parker, wearing a stylish red
frock-coat, adopts a protective
attitude towards his little sister in
this very fine portrait by
Reynolds, a close friend of the
Parker family of Saltram.

Opposite:
Joshua Reynolds (1723-92)
Miss Jane Bowles 1775; Oil on
canvas; 361/8 x 28in. (92 x 71cm.)
London; Wallace Collection.
Pretty little Jane Bowles, the
daughter of an amateur artist,
Oldfield Bowles, was born in
1772, so would have been just
three when Reynolds painted her.
Reynolds' approach to the many
children he painted, while
verging on the sentimental, was
also avuncular.

ket throughout Europe, and influenced lesser artists' treatment of similar sub-
jects until the end of the 19th century. At their best, in works like *Peasant Boy
Leaning on a Sill*, Murillo's pictures combined fine portrait painting with all
the actuality of a directly observed situation. This could not be said for many
later artists who, despite being recognized for the quality of their child studies,
tended to paint them very much in keeping with the ethos of their period.
Working in early 18th-century France, Antoine Watteau dressed his children

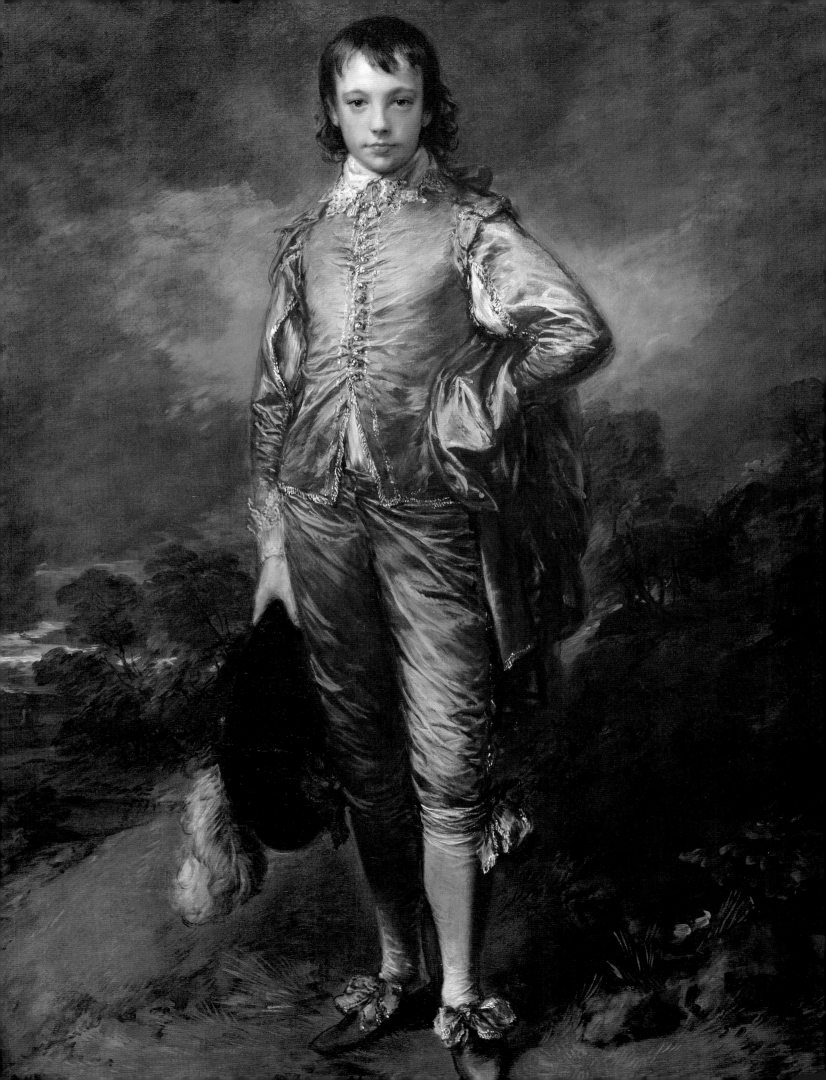

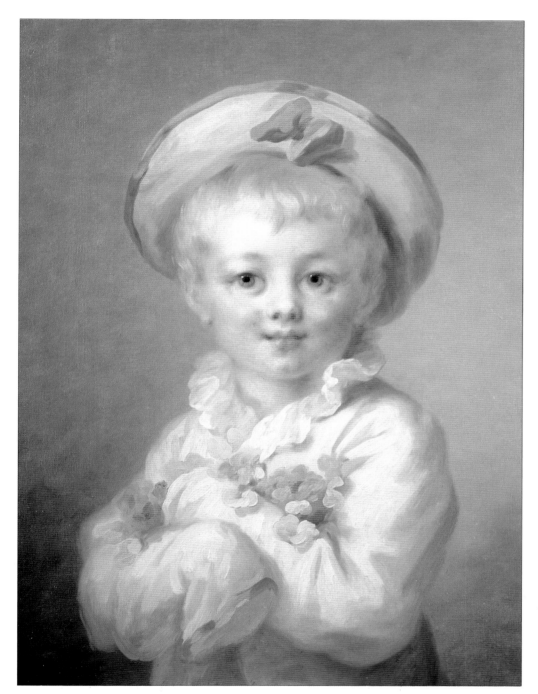

Opposite:
Thomas Gainsborough (1727-88)
The Blue Boy 1770; Oil on canvas;
70 x 48in. (178.5 x 122.4cm.).
San Marino, California: Henry E.
Huntington Library and Art
Gallery. This painting, a study of
Master Jonathan Buttall, teen-age
son of a rich London merchant,
helped set the seal on
Gainsborough's reputation as a
portraitist. Rather than simply
copying the style of Van Dyke,
which he greatly admired,
Gainsborough has given the boy
a richly romantic Cavalier
costume, while the portrait's
overall effect is lighter and more
elegantly informal than Van
Dyke's work.

Left:
Jean Honoré Fragonard (1732-1806) **A Boy as Pierrot** probably after 1789; Oil on canvas; 24 x 20in. (61 x 51cm.) London: Wallace Collection. The Pierrot, Harlequin or clown costume derived from the Italian *commedia dell'arte* was a popular dress for child studies from the 18th century right through to the 20th. Fragonard, tackling the theme when the French Revolution had made such frivolities unfashionable, was also unable to avoid the sentimental prettiness which was creeping into child studies at the end of the 18th century.

like little adults and portrayed them accordingly. Later in the century came artists like Jean-Baptiste Siméon Chardin and Jean Honoré Fragonard. Despite the differences in their styles — Chardin the painter of quietly ordered, beautifully observed and arranged objects, including people, often with a domestic background and Fragonard, his former pupil and a master of highly decorative and light-heartedly artificial pictures suited to the frivolity of life at the court of Louis XV — both artists tended to produce the sort of pictures that would sell well to the picture buyers of the day, rather than those based on direct observation of the characters of the children and young people they painted.

Jean-Baptiste Greuze, a contemporary of Fragonard and destined like Fragonard to die in poverty and neglect, his work totally out of fashion in post-Revolution France, was also recognized in his hey-day for the quality of his tender, charming portraits of children, done with a hint of sweet mischievousness.

To get nearer to the idea of realistic portraiture of children in a domestic set-

Overleaf:
John Everett Millais (1829-96) **Bubbles** Oil on canvas. England: Elida Gibbs Collection. Technically a fine painting, Millais' *Bubbles* has long suffered the sneers of the critics because of its sentimentality, which lies in the title as much as in the painting, and the fact that for decades it helped sell thousands of bars of Pears soap.

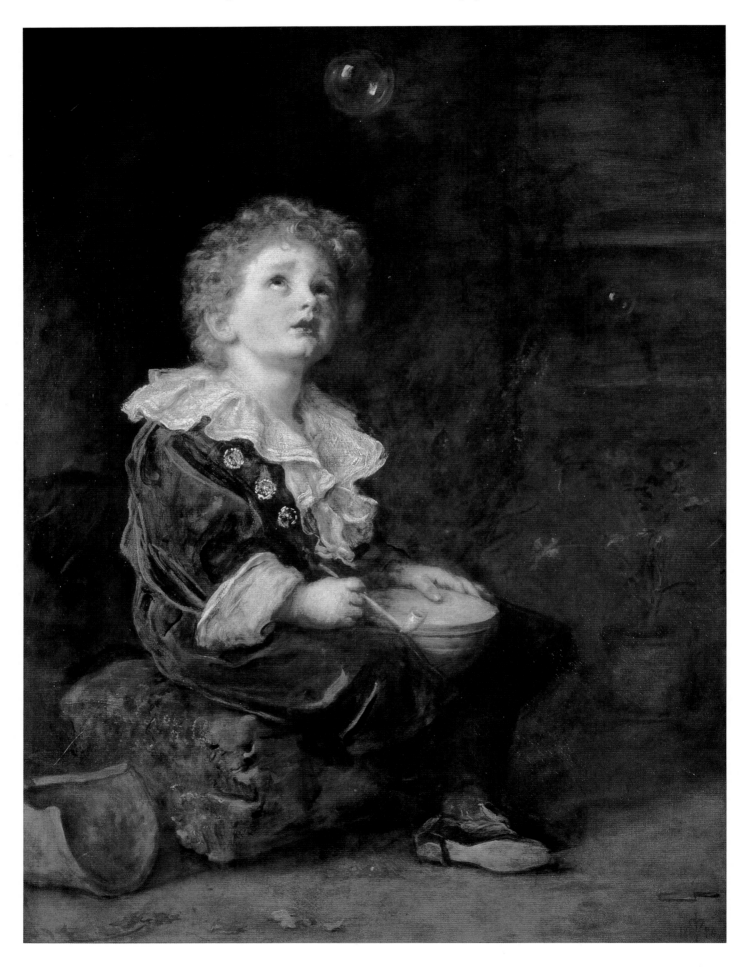

Previous page:
Thomas Sully (1783-1872) **The Torn Hat** 1820; Oil on panel; 19 x 14 1/2 in. (48.2 x 36.8 cm.). Boston: Museum of Fine Arts, gift of Belle Greene and Henry Copley Greene in memory of their mother, Mary Abby Greene. As a portrait painter, the American artist Thomas Sully was much influenced by Thomas Lawrence, the most celebrated portraitist in Europe at the end of the 18th century. While this fine study of a boy may owe something to Lawrence it owes much more to Sully's adept handling of light and shade.

Right:
Edouard Manet (1832-83) **The Fifer** 1866; Oil on canvas; 64 5/8 x 38 in. (164 x 97 cm.) Paris, Musée d'Orsay. Described by Emile Zola as a 'petit bonhomme' who 'puffs away with all his heart and soul', the boy whom Manet vividly portrays in flat, bright colours against a startlingly plain background has become one of the finest child studies of its period. Not that many of Manet's contemporaries would have agreed: the painting was refused at the Paris Salon of 1866.

Opposite:
Pierre Auguste Renoir (1841-1919) **Mlle Legrand** 1875; Oil on canvas; 32 x 23 1/2 in. (81.6 x 59.3cm.)
Philadelphia: Museum of Art, Henry P. McIlhenny Collection. Charming paintings like this one of a daughter of a well-off Paris family helped secure Renoir commissions among the rich bourgoisie of post-Imperial Paris. Unlike many of his contemporaries, especially the struggling Impressionists, Renoir had several rich patrons who were happy to draw their friends' attention to the glorious colours and superb detail of his portraits.

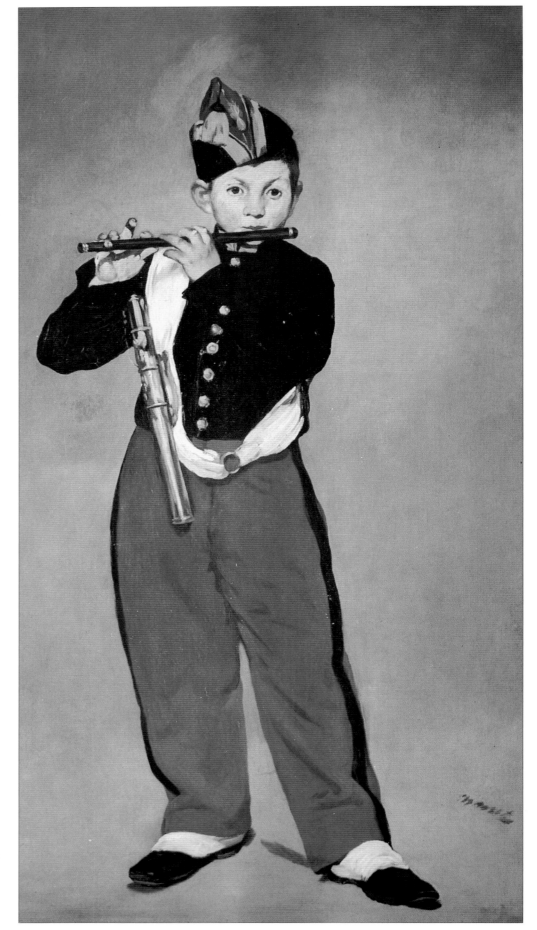

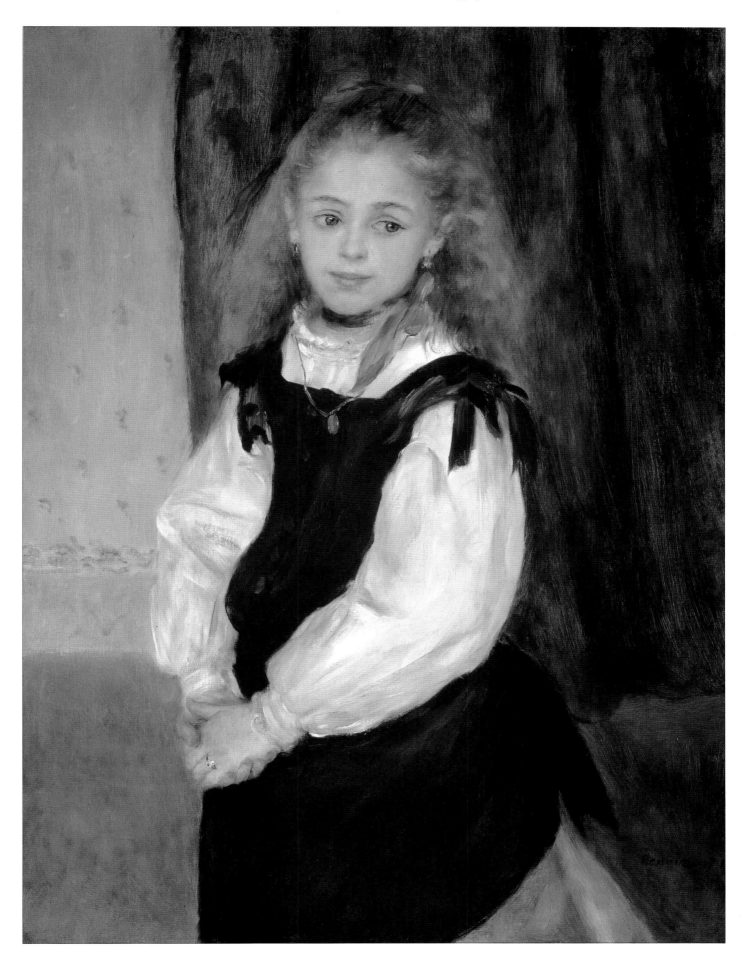

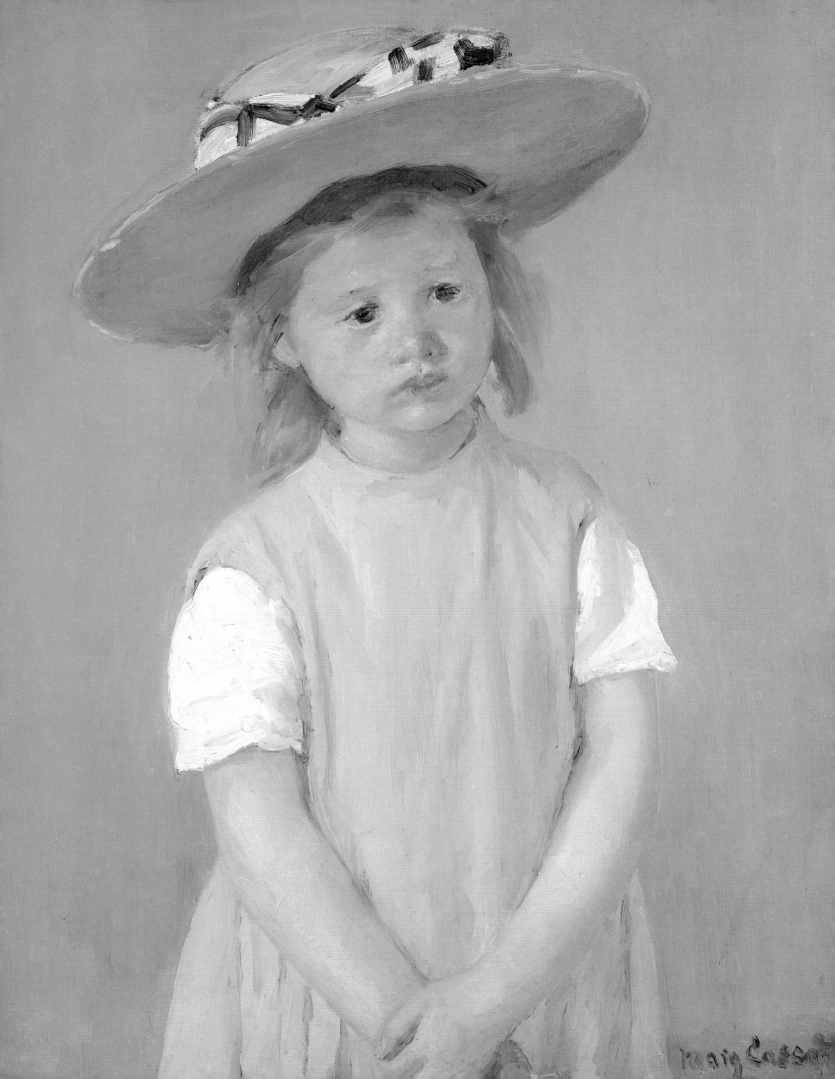

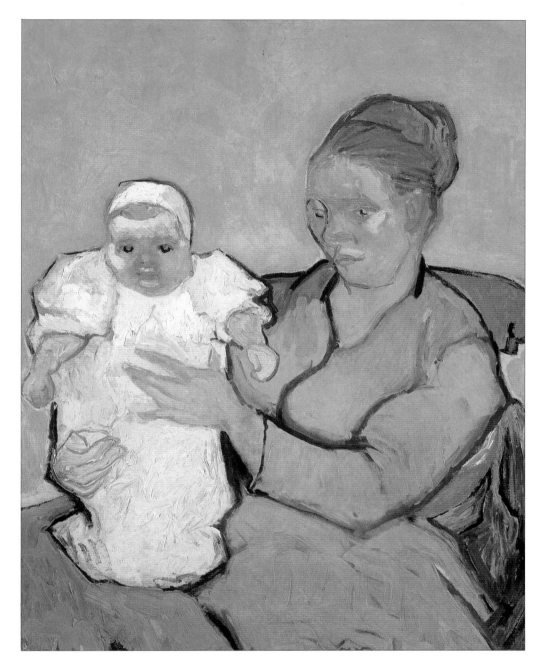

Opposite:
Mary Cassatt (1844-1926) **Child in a Straw Hat** *c*.1886; Oil on canvas; 25 3/4 x 19 1/2 in. (65.3 x 49.5 cm.) Washington: National Gallery of Art, Collection of Mr and Mrs Paul Mellon. This delightful study of a little girl, perhaps becoming a little impatient with the business of being painted, is a particularly fine example of the art of Mary Cassatt, many of whose intimate studies of childhood were done within her own family circle, where she used her nephews and nieces as her models.

Left:
Vincent van Gogh (1853-90) **Madame Roulin and her Baby** 1888-9; Oil on canvas; 36 3/8 x 28 7/8in. (93 x 73.5cm.) Philadelphia: Museum of Art, bequest of Lisa Norris Elkins. The closest friendships van Gogh made during his time in the south of France were with a local postman called Roulin and his family. Even when it came to setting the Roulin family's latest child on canvas, van Gogh did not use such appropriately 'baby' colours as delicate blues and pinks, choosing instead the wonderfully vivid yellow of his favourite sunflowers for the background and a rich green for Madame Roulin's dress.

Overleaf:
Cecilia Beaux (1855-1942) **Ernesta (Child with a Nurse)** 1984; Oil on canvas; 50 1/2 x 38 1/8in. (128.3 x 96.8 cm.) New York: Metropolitan Museum of Art, Maria Dewitt Jesup Fund. In this study in shades of 'white on white', Beaux, an outstanding Philadelphia portrait painter who studied for a time in Paris in the late 1880s, has brilliantly composed her picture so that we are looking at the world from a child's eye-level.

ting, however, one needs to cross the Channel. William Hogarth, whose satiric studies of the street and home life of his time give a vivid picture of life in Britain in the first half of the 18th century, also produced some superb studies of children, among them *The Graham Children*.

Hogarth's portrait study of the four children of Daniel Graham, apothecary to the Chelsea Hospital in London, is also an allegory of childhood: the Cupid on top of the ornate clock in the picture holds a scythe, suggesting the passing of time, but the innocence of childhood is preserved by Hogarth's making it clear that the splendid tabby cat flexing his claws on the back of a chair will not kill the children's pet bird because it is safely in a cage.

One of the great masters of 18th-century English portraiture, especially of children, was Sir Joshua Reynolds, first President of the Royal Academy. Reynolds imbued his canvases with the splendid grandeur of classical painting while giving intimate glimpses deep into the character and personalities of his sitters. He was particularly adept at painting children, to whom he gave an air of seriousness and dignity in much keeping with the spirit of the age, but

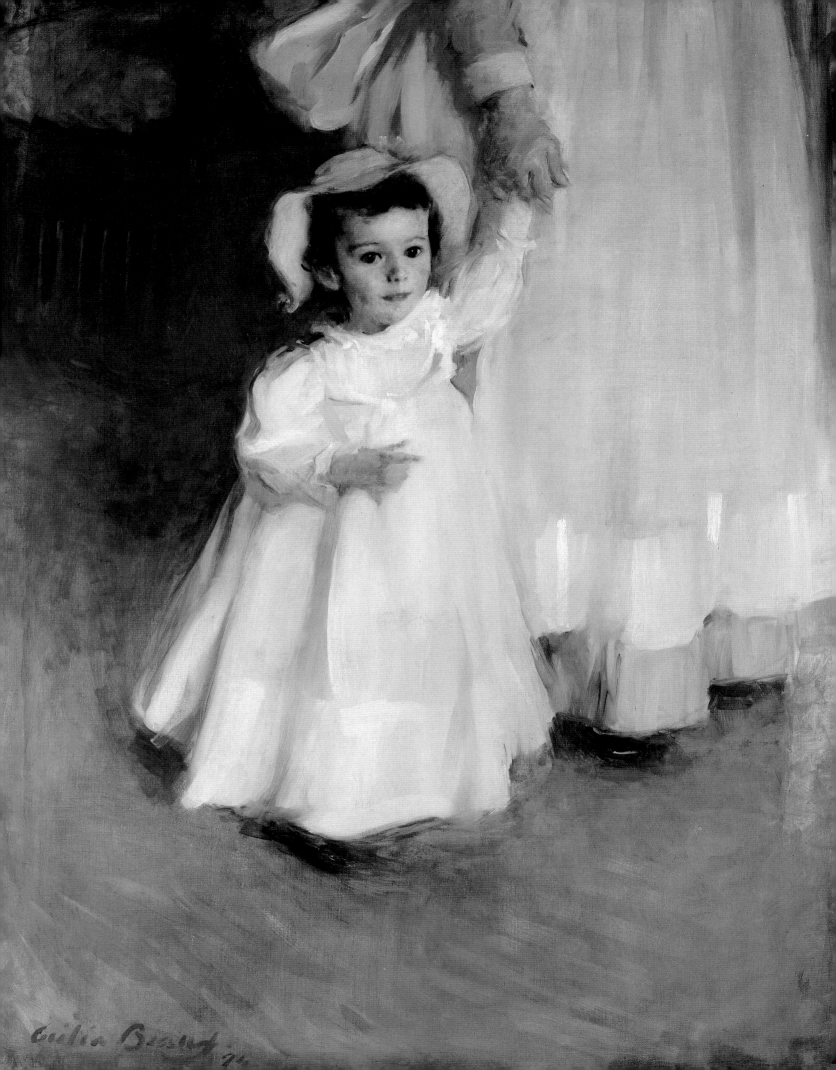

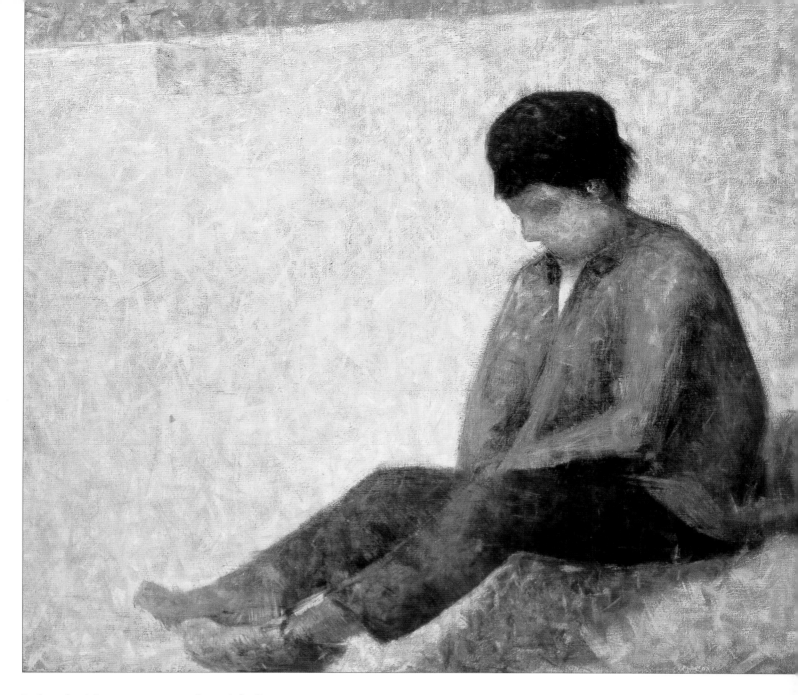

imbued with a great warmth and feeling.

But Reynolds was working in an age when naturalism in child studies was beginning to give way to sentimentality, the flip side of the coin of the Romantic movement. This was the time when the French word 'espièglerie', meaning a playful or roguish trick, was re-coined to describe the work of artists like Reynolds in England and Greuze in France. (There is among the Wallace Collection's many examples of the work of Greuze a painting called *Head of a Boy* whose original title was *Espièglerie*, translated into English as *The Mischief-Maker*.)

In his later pictures, Reynolds tended to over-emphasize the sweet innocence of childhood. Pictures like *The Age of Innocence* and *Miss Jane Bowles*, while charming in themselves, helped opened the floodgates to all that we now find least attractive in 19th-century child art, with its sanitized sweetness and over-emphasis on innocence and goodness. Miss Bowles, painted by Reynolds with her arms round a charming little dog, is an artistic first cousin of Greuze's children, whom he painted with dogs, doves, lambs and many other creatures. Their influence on the genre painters of 19th-century Europe was immense, with the combination of children and animals being one of the

Georges Seurat (1859-91) **Boy Seated on the Grass** *c*.1883; Oil on canvas; 25 x 31 1/4 in. (63 x 79.5cm.) Glasgow: Art Gallery and Museum. Seurat's first major painting, *Une Baignade, Asnières*, was a working out of his revolutionary theories on the effects of contrasted colours when set side by side on canvas, which came to be called Pointillism. This study was painted when Seurat was making his figure studies for the *Baignade* painting.

John Singer Sargent (1856-1925)
The Daughters of Edward D. Boit 1882; Oil on canvas; 87 x 87in. (221.85 x 221.85 cm.) Boston: Museum of Fine Arts, gift of Mary Louise Boit, Florence D. Boit, Jane Hubbard Boit and Julia Overing Boit, in memory of their father, Edward Darley Boit. Florence, Jane, Mary and Julia Boit were aged between four and fourteen when they posed for this painting in the Paris apartment of their father, a rich Bostonian and friend of the artist. Sargent is not presenting an innocently idyllic view of childhood here; rather, he seems to be suggesting that growing up is as much a matter of coping with ominous shadows, secret corners and an isolation of self as it is of learning to play with one's siblings.

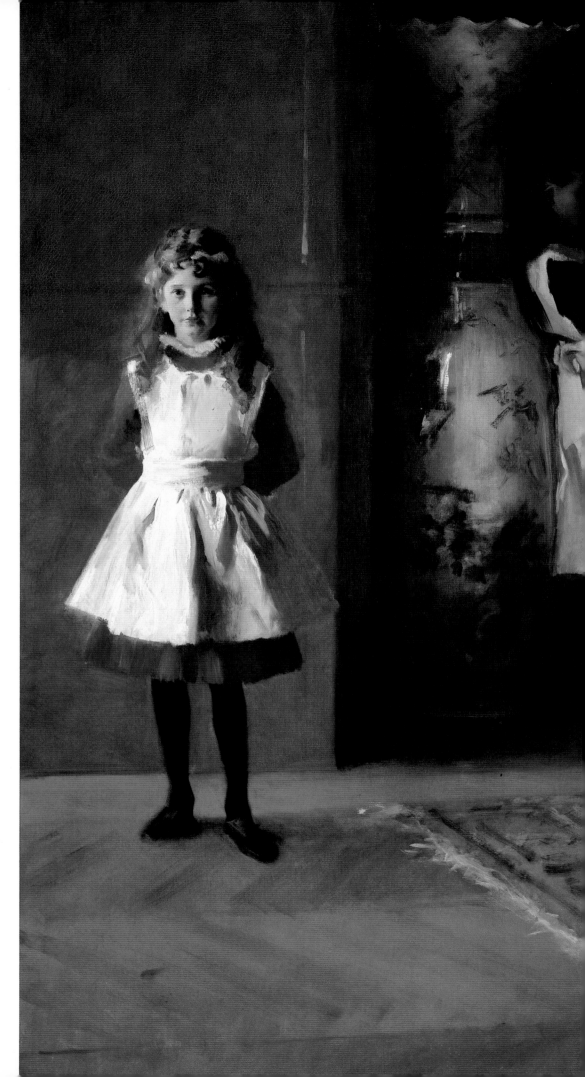

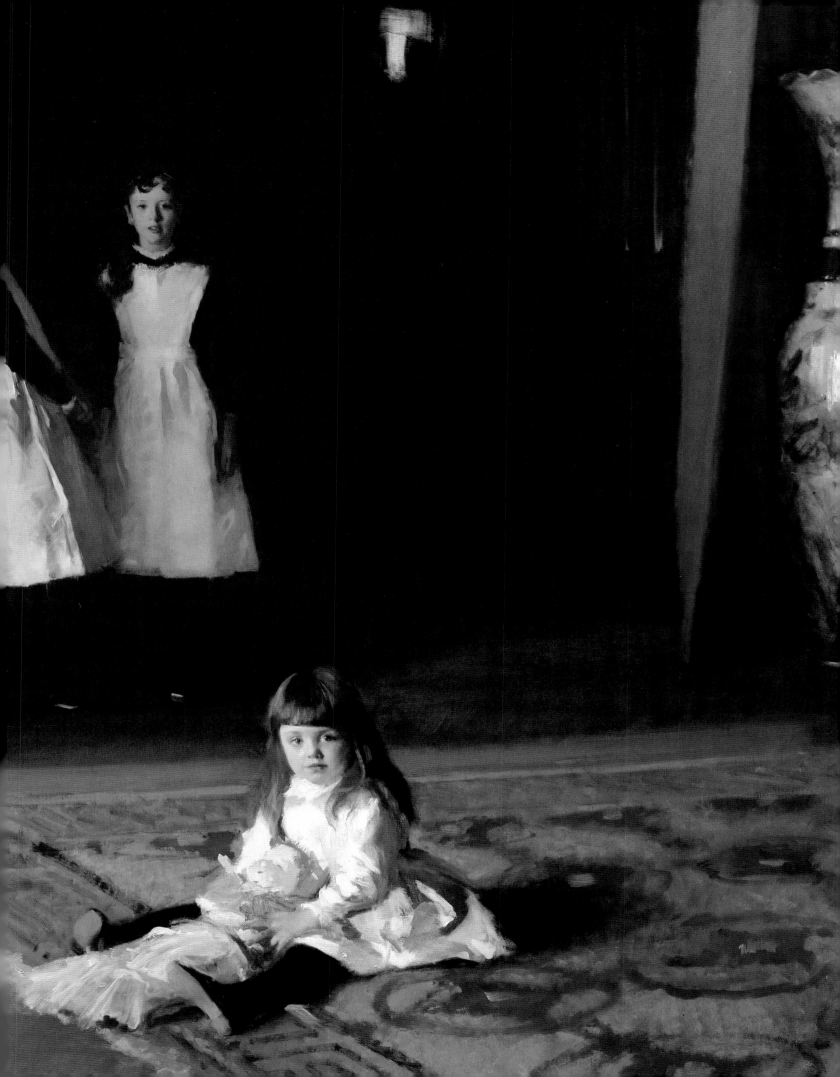

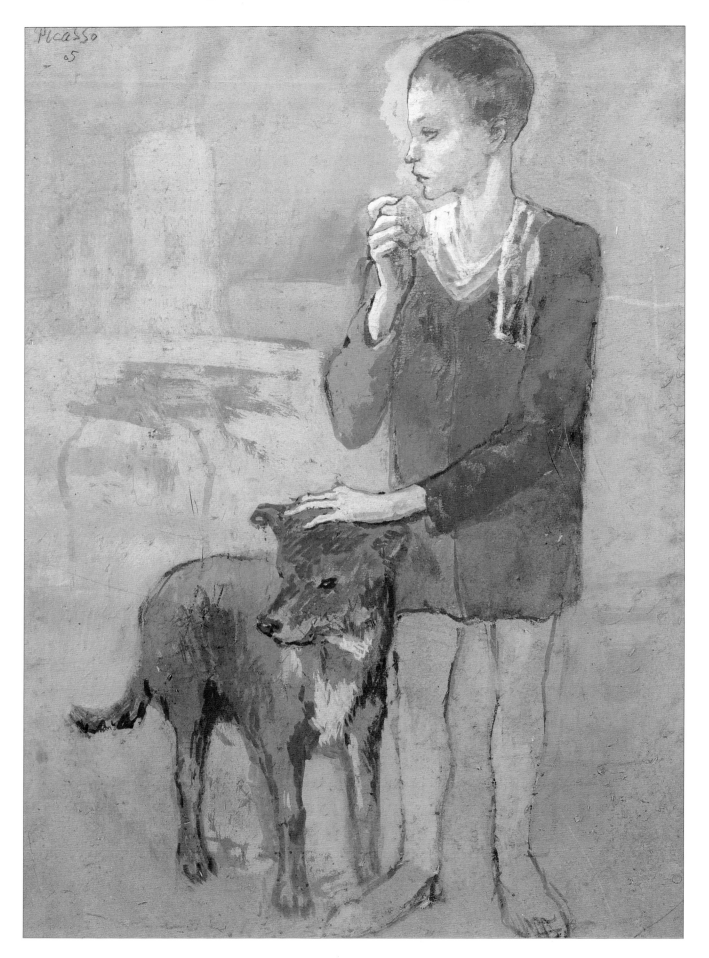

most frequently painted in European child art.

Reynolds' contemporary, Thomas Gainsborough, was more influenced by the Dutch and Flemish artists of the 17th century than was Reynolds. His landscapes show the influence of the great Dutch landscape painters of the 17th century and such portraits as *The Blue Boy* clearly show an indebtedness to van Dyck. *The Blue Boy*, dressed in the silks and lace of a Carolingian Cavalier, is thought to have been posed for by the teenage son of a rich hardware merchant, a good friend of Gainsborough. The painting was to win Gainsborough the admiration of everyone who was rich and fashionable in London, including the Royal Family, and helped establish his successful career as a portrait painter.

This combination of the richly romantic and the sweetly tender in British and European child portraiture, while it remained fashionable until the end of the 19th century, came to be overlaid with the idea that, as far as the portrayal of children was concerned, total simpering innocence was all that mattered.

Millais, painting his *Bubbles* and *Cherry Ripe*, set standards of mawkish sentiment which lesser artists were only too eager to emulate because it sold — not just in itself but in the form of prints and engravings. A colour reproduction of *Cherry Ripe*, inserted into *The Graphic* in 1880, sold 600,000 copies. Victorian entrepreneurs soon discovered that this kind of art sold other things, too: *Bubbles*, used to promote Pears soap, must be among the most successful child pictures ever produced for that very special branch of painting, advertising art.

The Impressionists and artists who followed them came to the aid of children in art. The leading artists of the Impressionist movements were all members of French bourgeois society, in which the family was the pivot round which social life moved. Children were included quite naturally and in an unaffected manner in the Impressionists' paintings of domestic life.

Renoir, while he could paint brilliantly effective set pieces of the families of wealthy patrons of the arts, was just as good at painting charmingly individual portraits of the children of these families, setting them against backgrounds suited to their age rather than their social status.

Mary Cassatt's studies of children, many of them done outside in true Impressionist *en plein air* fashion so that they became suffused with a clear sunlight, were intended by the artist primarily as exercises in drawing and in composing a picture. So good was she at observing the subtle nuances of emotion in a child's face, however, that her best studies, like *Child In a Straw Hat* or *The Sisters*, became perfect evocations of childhood.

Despite keeping background details to a minimum in these studies, Mary Cassatt's children, like Renoir's, were always clearly from well-off, middle-class homes. In contrast, Paul Gauguin, Vincent van Gogh and other artists of the period were producing studies which concentrated on recording a child or baby as the artist observed them, without feeling the need to indicate any particular social background.

Van Gogh's few studies of childhood painted in the last years of his life grew out of his determination to do a portrait of every member of the family of a postman called Joseph Roulin, whom he had come to know while living in Arles. The children in the family were eleven year old Camille and four months old Marcelle. The family, van Gogh wrote to his brother, were 'all characters and very French... If I manage to do this *whole family* better still, at least I shall have done something to my liking and something individual.'

Both styles found effective followers in the 20th century, Modigliani and Picasso among the finest of them. On the whole, the art of our own day has ignored children as a suitable subject for study, perhaps because the psychological portrait is no longer in fashion.

Opposite:
Pablo Ruiz y Picaso (1881-1973) **Boy with a Dog** 1905; Gouache on brown card; 221/4 x 16in. (57 x 41cm). St Petersburg: Hermitage Museum. This quiet little study of a frail urchin's friendship with a dog is typical of the work Picasso did in his early years in Paris at the turn of the century. Intent on portraying the life of the ordinary, often poor people he saw in the great city's streets, he first used a palette dominated by blues - his so-called 'Blue Period' - and later allowed the quiet, even drab, fawns, greens and pinks of his 'Pink Period' to creep in. His figures were elongated, influenced partly by Spanish art, particularly that of El Greco, and partly by the Italian Mannerist style.

Right:
Amedeo Modigliani (1884-1020)
Boy in Shorts *c.*1918; Oil on canvas; 39¼ x 25½in.
(100 x 65cm.) Private collection. This clearly middle-class boy's neat black shorts and smart Norfolk jacket suggest that his portrait has been commissioned from Modigliani: there is a more formal air about this painting than Modigliani put into *The Little Peasant*. The warm, light colours of the south, strongly reminiscent of Cézanne's work in the same part of France, are very much evident in this portrait.

Opposite:
Amedeo Modigliani (1884-1920)
The Little Peasant 1919; Oil on canvas; 39¼ x 25¼in.
(100 x 64.5cm.) London: Tate Gallery. A move from the cool of northern France to the warm south brought sunlight and warmer colours into the Italian Modigliani's late paintings, of which this study of a peasant boy is a good example. Although Modigliani has noted the boy's too-small jacket and his open, sun-touched face, the painting is not a portrait so much as an exploration of mass and volume and the effect of light in painting.

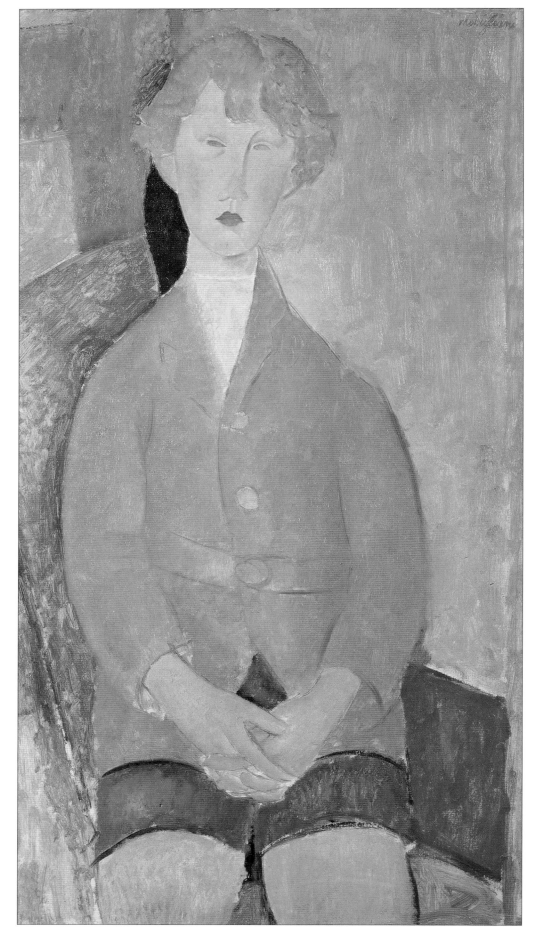

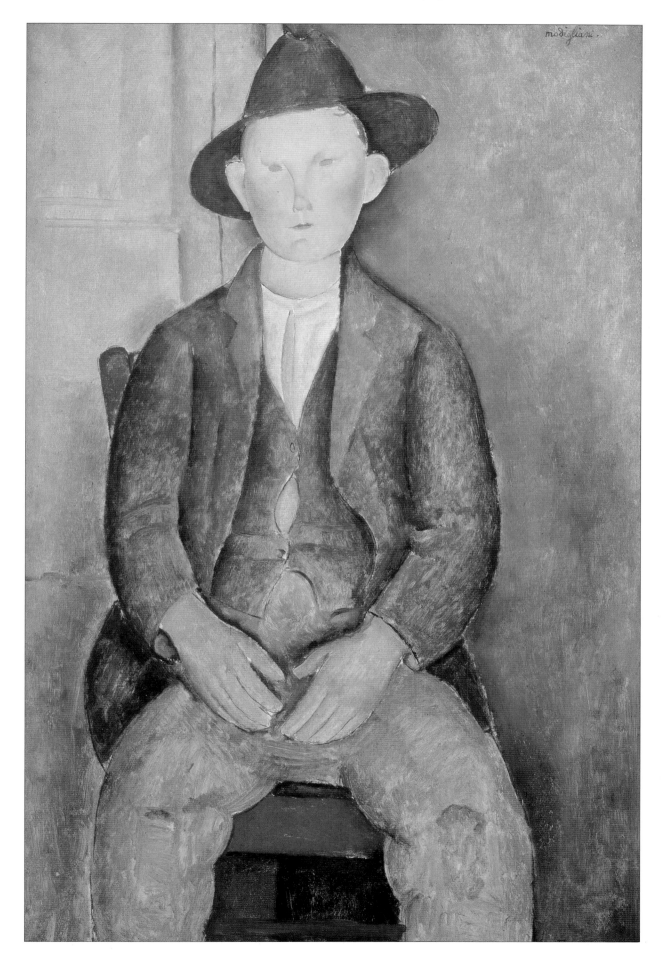

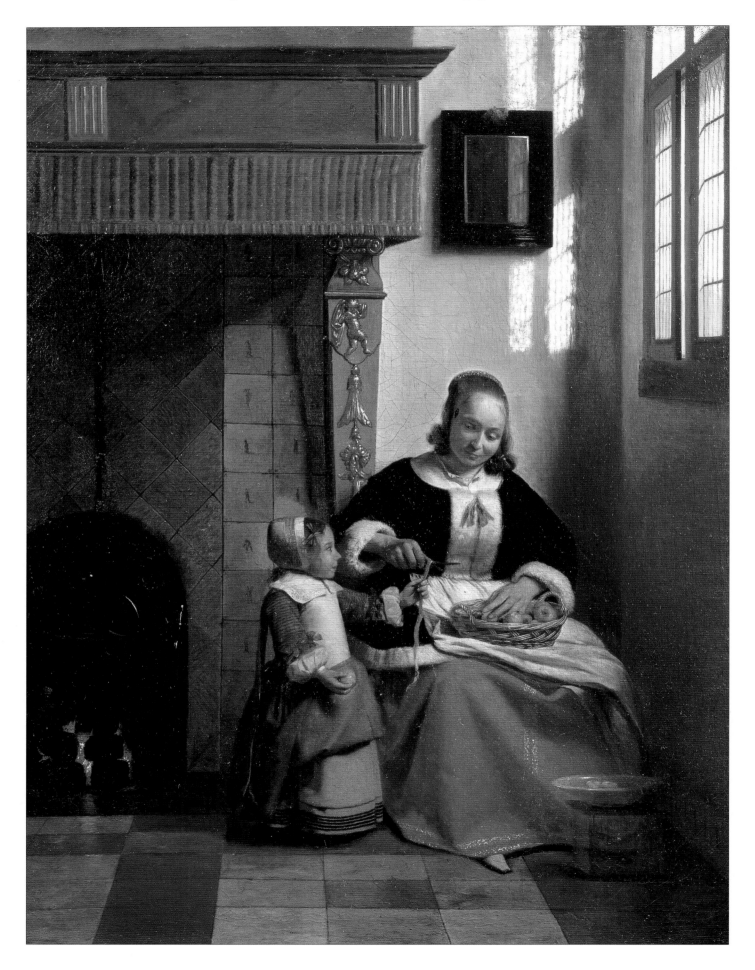

CHILDREN GROWING UP

From the baby in its cradle to the boy or girl verging on adulthood, the developing child has been a regular theme in art, being particularly popular in those countries with a confident, thriving middle class eager for pictures with a domestic background to enhance the decoration of their homes. The most immediately attractive pictures in this tradition are those which capture both the fleeting moments in an individual child's development and the steps along the road to adulthood taken by every child. They are the pictures which have a quiet intimacy allied to a wonderful capacity to jog the memories of people who have brought up their own children, reminding them of what it was like.

Turn the pages of a book reproducing Rembrandt's drawings, for instance, and you'll come across the fleeting moments, wonderfully caught in a few lines of chalk or ink: *Two Studies of a Baby with A Bottle*, or *Two Women Teaching a Child to Walk*, or *Woman Carrying a Child Downstairs*.

Look closely at the delicately detailed domestic interiors of Pieter de Hooch and you will discover the artist has noticed all sorts of small milestones along the road to adulthood. The tender smile on the face of the mother in *A Woman Peeling Apples* is tinged with a certain quiet triumph: the length of apple peel she is handing her small daughter is clearly the whole peel, taken unbroken from the apple. We know that the little girl will have watched, scarcely daring to breathe, as the peel slowly twisted away from the apple in her mother's hand.

Rembrandt's and de Hooch's pictures fall within two of the themes which recur in art depicting the developing child: the baby in the nursery, and the importance of learning by example. Other themes which artists of every generation have tackled include the education of the child, learning about life outside the home, the sick child and the end of childhood.

The baby in its cradle, or being fed or bathed by its mother, has been drawn and painted by many artists since the Flemish and Dutch artists of the 16th and 17th centuries took the theme out of the context of religious art and set it firmly in a domestic environment. Jan Steen even managed to have a foot in both camps in his typically lively picture *The Christening Feast*: the baby's cradle is in one corner of the picture, but the baby, the reason for the feast, has been taken out of it so that he may be held up, stiffly wrapped in swaddling clothes, for the guests to admire.

The French artist, Nicolas-Bernard Lépicié, did several pictures of the mother and child theme, in the delicately charming style of pre-Revolution France, his *A Mother Feeding Her Child* being a particularly well-observed study.

Pieter de Hooch (1629-after 1684) **A Woman Peeling Apples** *c*.1663; Oil on canvas; 275/8 x 211/4in. (70.5 x 54.3cm.) London: Wallace Collection. This delightful study is typical of the delicately observed, wonderfully light-filled work of the Dutch artist de Hooch, who was born in Rotterdam and spent most of his working life in Delft and Amsterdam. His paintings have become a superbly detailed record of domestic and family life in 17th-century Holland.

Overleaf:
Jan Steen (1625/6-1679) **School for Boys and Girls** *c*.1670; Oil on canvas; 32 x 421/2in. (81.7 x 108.6cm) Edinburgh: National Gallery of Scotland. Although this riotous scene is perhaps not typical of school life in 17th-century Holland, it is certainly typical of the lively, action-packed genre scenes which were the prolific Steen's speciality. Steen, who was born and died in Leiden, was also a tavern keeper for a time, perhaps just another way of expressing his obvious delight in observing people enjoying themselves in crowded rooms.

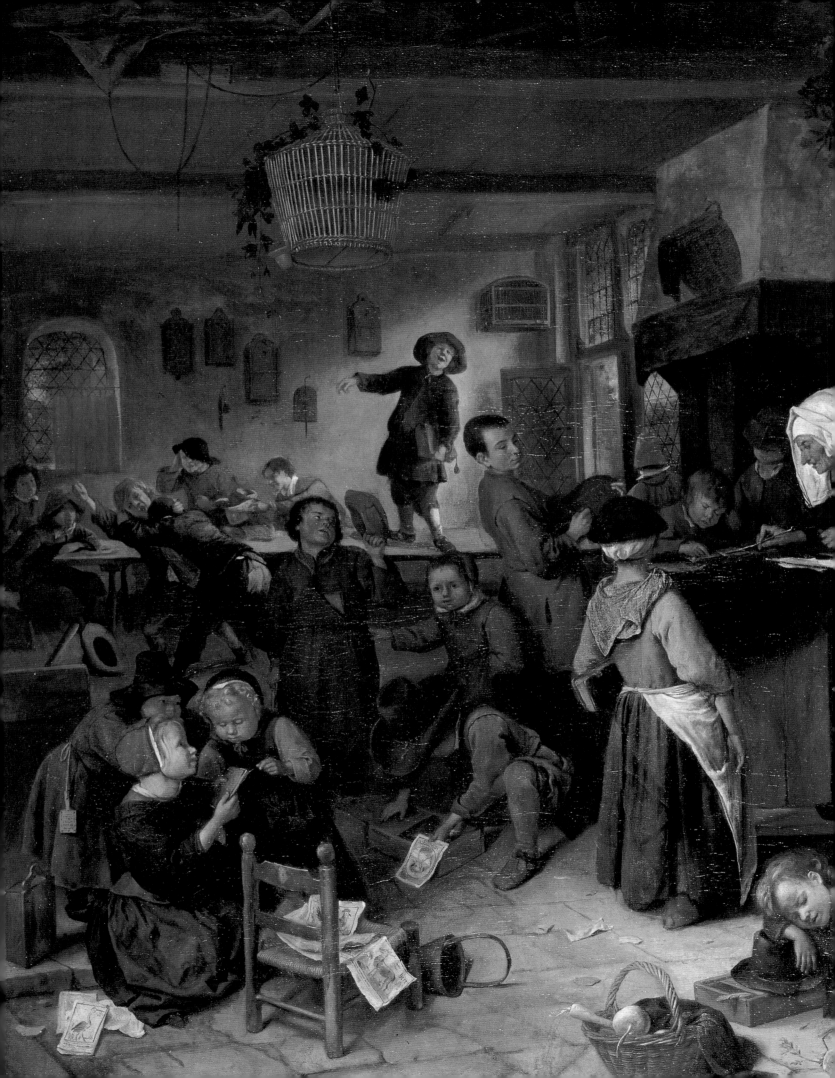

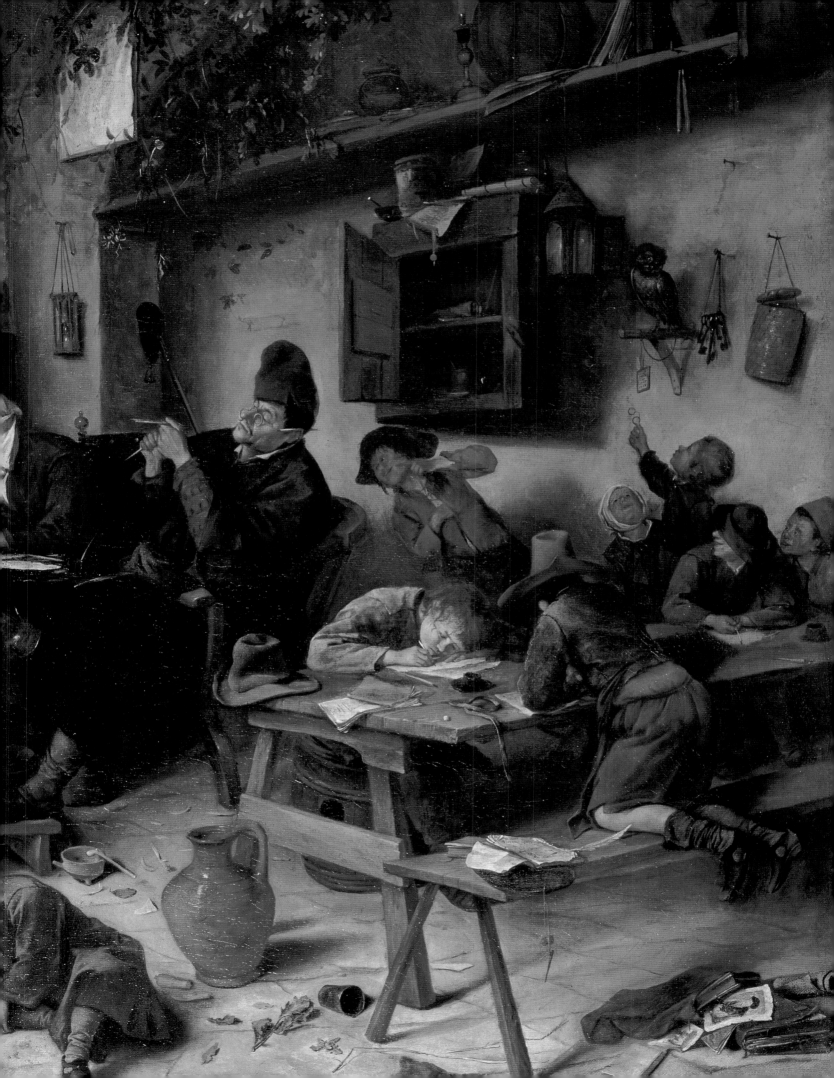

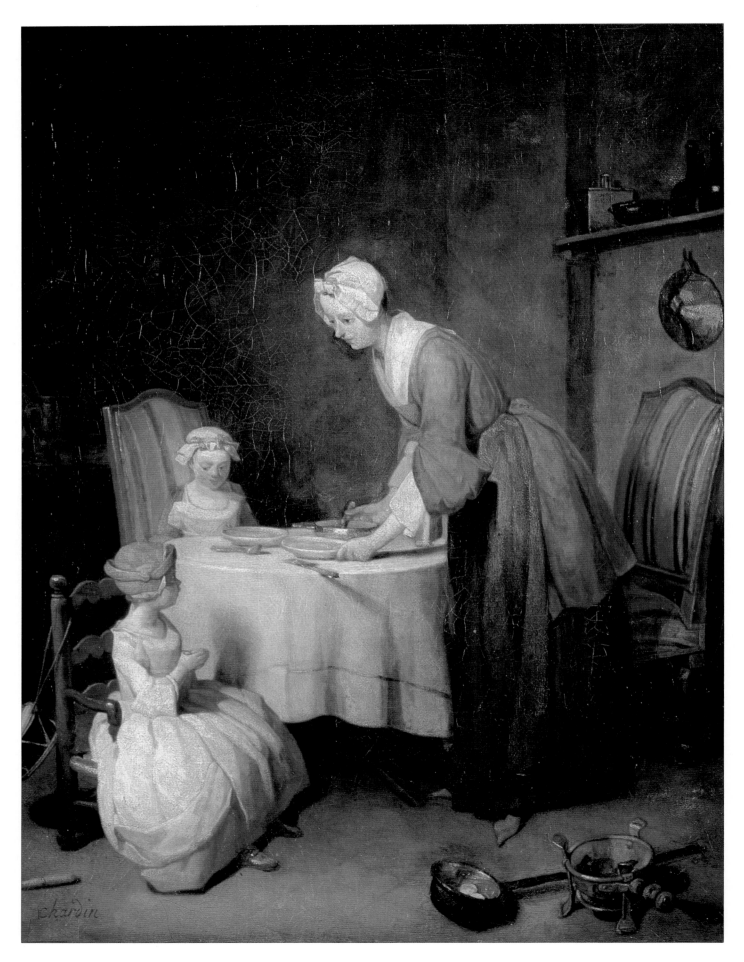

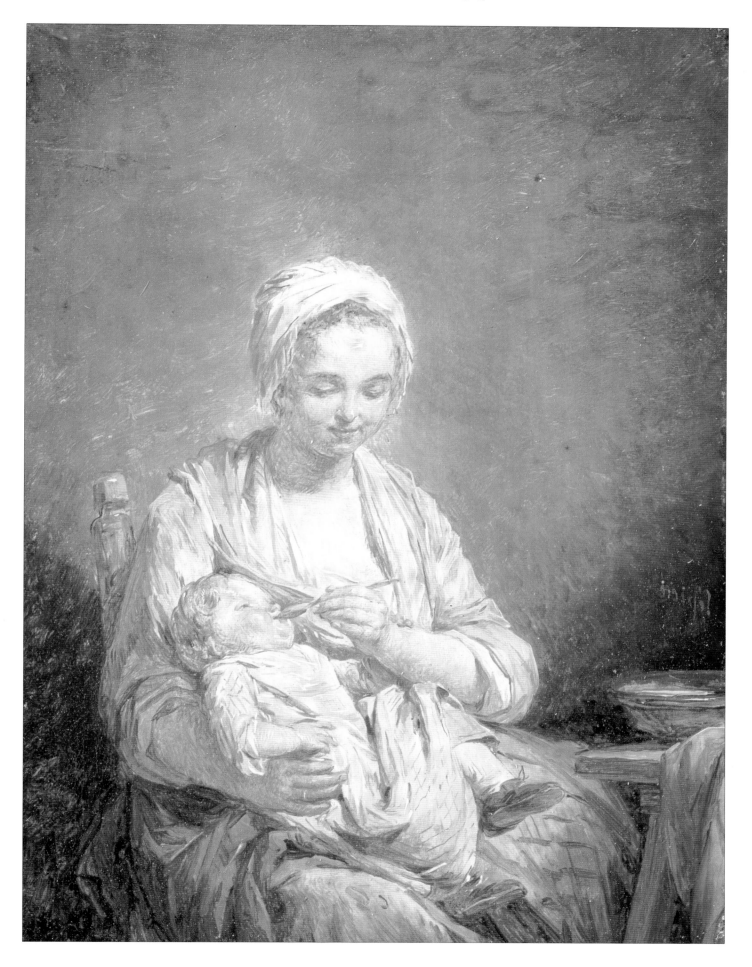

Previous page left:
Jean-Baptiste-Siméon Chardin
(1699-1779) **Grace Before Meat**
1744: Oil on canvas; 191/2 x 15in
(49.5 x 38.4cm). St Petersburg:
Hermitage Museum. Chardin
was among the first artists in
18th-century France to paint
realistic domestic interiors, in
the style of Dutch artists of the
previous century.

Previous page right:
Nicolas-Bernard Lépicié (1735-
1784) **A Mother Feeding Her
Child** c.1774; Oil on panel;
6 x 43/8in. (15.2 x 11.1cm.)
London: Wallace Collection.
Paris-born Lépicié's career took
him to the heights of a profes-
sorship at the French Academy
and the title of 'premier peintre
du roi'; he remained a genre and
history painter.

Right:
Pierre Edouard Frère (1819-86)
**On the Way to School in the
Snow** 1879; Oil on canvas.
London: Galerie George. English
art critic John Ruskin was once
so overwhelmed by a child study
by Frère that he burbled 'Who
would have believed it possible to
unite the depth of Wordsworth,
the grace of Reynolds and the
holiness of Angelico?

Opposite:
James Archer (1824-1904)
**The Little Girl Who Sat for van
Dyck** 1868; Oil on canvas.
London: Whitford and Hughes.
James Archer was one of many
British artists who made an
excellent living working in the
specialized genre subject of
children during the 19th century.
The main influence on this
picture was clearly the Pre-
Raphaelite school, as the girl's
gloriously red hair and such
details as the rose in her hand
and the rose on the floor
beside her, indicate.

Painting the mother and child theme in art reached a high level of sensitivity
and tenderness in the work of the Impressionists. One of the finest artists
working with the theme was Mary Cassatt, whose many studies of children
and their mothers in the nursery were painted with a great sensitivity entirely
free of the sentimentality which so often spoilt the work of lesser artists in the
19th century.
 The novelist and art critic Joris-Karl Huysmans, repelled by current baby
portraits, the fault of 'a whole crew of French and English daubers who have

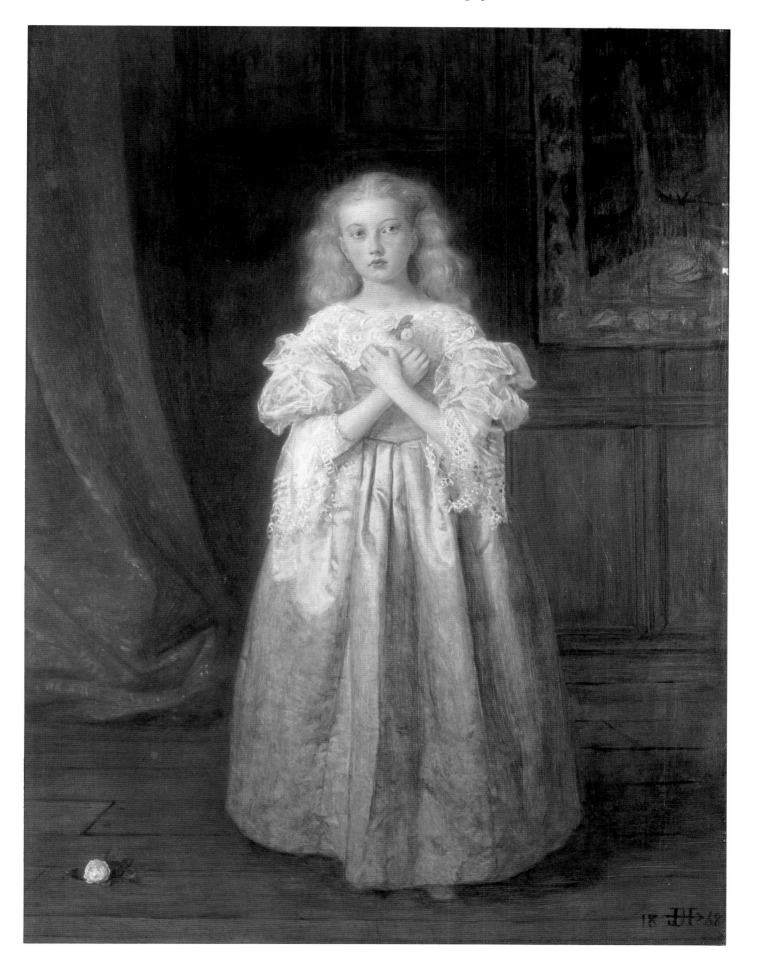

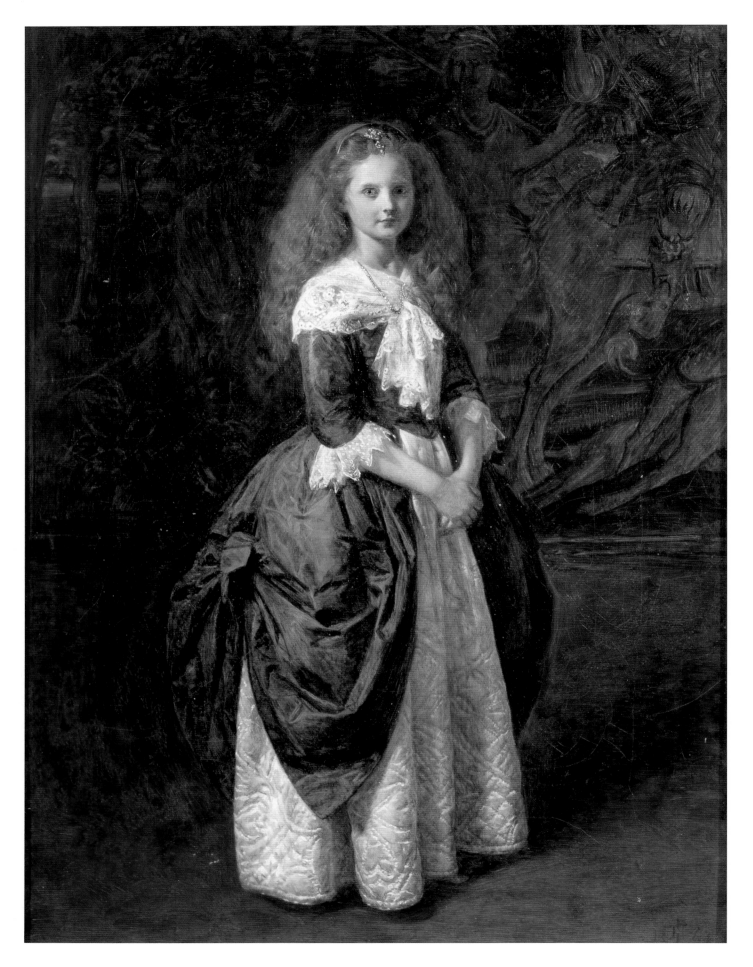

painted them in stupid and pretentious poses', encountered Mary Cassatt's work in the 1881 Impressionist exhibition in Paris. Huysmans declared enthusiastically that 'for the first time in my life, thanks to Miss Cassatt, I have seen images of ravishing children...painted with a kind of delicate tenderness which is completely charming'.

One of Cassatt's contemporaries who also did many fine paintings on the mother and child theme was Berthe Morisot, whose *The Cradle* was included in the first Impressionist exhibition in Paris in 1874. Although Morisot hid the baby in her picture behind the cradle's delicate net drapery, she allowed enough of it to be seen for the viewer to recognize how cleverly she depicted the typical attitude of a sleeping baby, one arm resting by its head on the pillow.

Among other Impressionists who painted children in the nursery, Claude Monet and Pierre Auguste Renoir both did many studies of their own families. Monet painted his son Jean in his cradle and in the nursery several times while Renoir seems hardly to have stopped drawing and painting his children, to judge by the great many delightful pictures of Pierre, Claude and Jean as

Above:
William Bromley (fl. 1835-88)
Ready to Fight Oil on canvas. London, Roy Miles Gallery. Children displaying an endearing naughtiness, as in this picture of a group of boys about to come to blows over a game of marbles.

Opposite:
James Archer (1824-1904)
My Great Grandmother Oil on canvas. London: Guildhall Art Gallery. Archer here romanticizes the memory of his great grandmother.

babies and infants to be found in the world's art collections.

The Impressionists also included in their output some pleasant variations on the 'learning by example' theme. Camille Pissaro's glimpse of everyday life, *Woman Hanging Up Washing*, caught the woman as she turned from the washing line to say something to the child sitting on the grass at her feet.

Where Pissaro, a true Impressionist, set his picture in an atmosphere of airy light and movement, the 18th-century Frenchman, Jean-Baptiste Siméon Chardin, though he depicted the same quiet intimacy between mother and child, had been more concerned to do it within the framework of a domestic still life. His *Grace Before Meat* freezes the moment in which the mother, poised over the dishes on the table, waits for her small daughter to finish saying grace before handing out the food.

Chardin had begun his artistic career as a painter of still lifes of such fine quality that his work had been mistaken for that of Flemish master and continued to use the still life approach when he began painting portraits. He used the theme of the education of the child in several of his portraits, including one of a little boy with his governess and the delightful *Child With a Top* (actually a portrait of the aristocratic Auguste-Gabriel Godefroy). The picture captures the moment when the boy has abandoned his quill, ink, paper and book to take up a small spinning top he has found in the drawer of his desk.

The theme of the child learning had long had a place in art.

Previous pages:
William Bromley (fl. 1835-88)
Making a Posy Oil on canvas.
Christie's, London. The romantic innocence of country life was a popular theme of 19th-century child genre painting.

Opposite:
Camille Pissarro (1830-1903)
Woman Hanging up Washing
1887; Oil on canvas. Paris: Palais de Tokyo.
Pissarro liked painting life's ordinary details, whether crowded city streets or, as here, a garden, probably the one at his house at Eragny.

Below:
Pierre Auguste Renoir (1841-1919) **Gabrielle and Jean** *c.*1895; Oil on canvas. Paris: Musée de l'Orangerie. Gabrielle and Jean both came into Renoir's life in 1894, Gabrielle Renard being hired as general maid and nurse for newly-born Jean, the second son of Renoir and his wife, Aline.

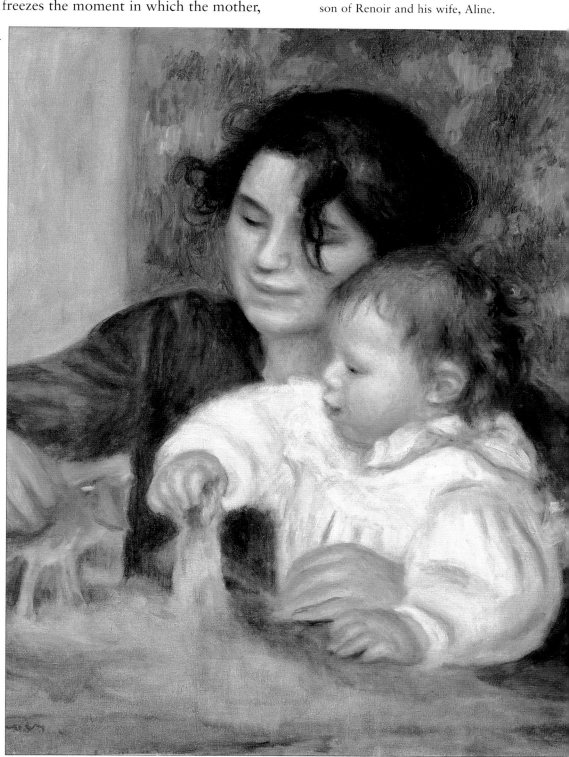

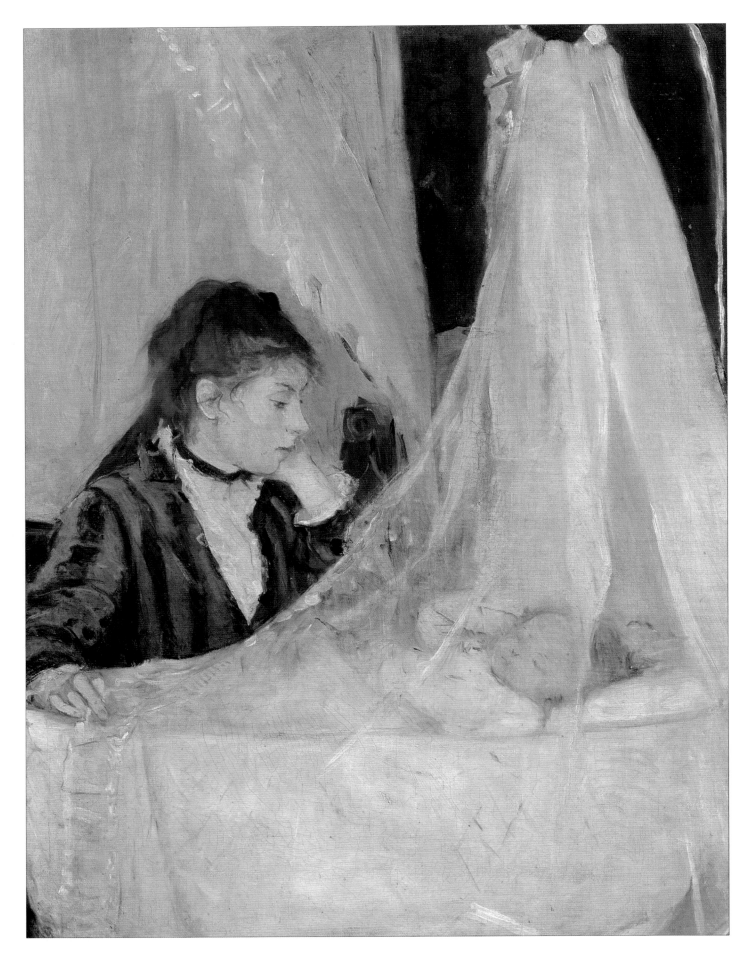

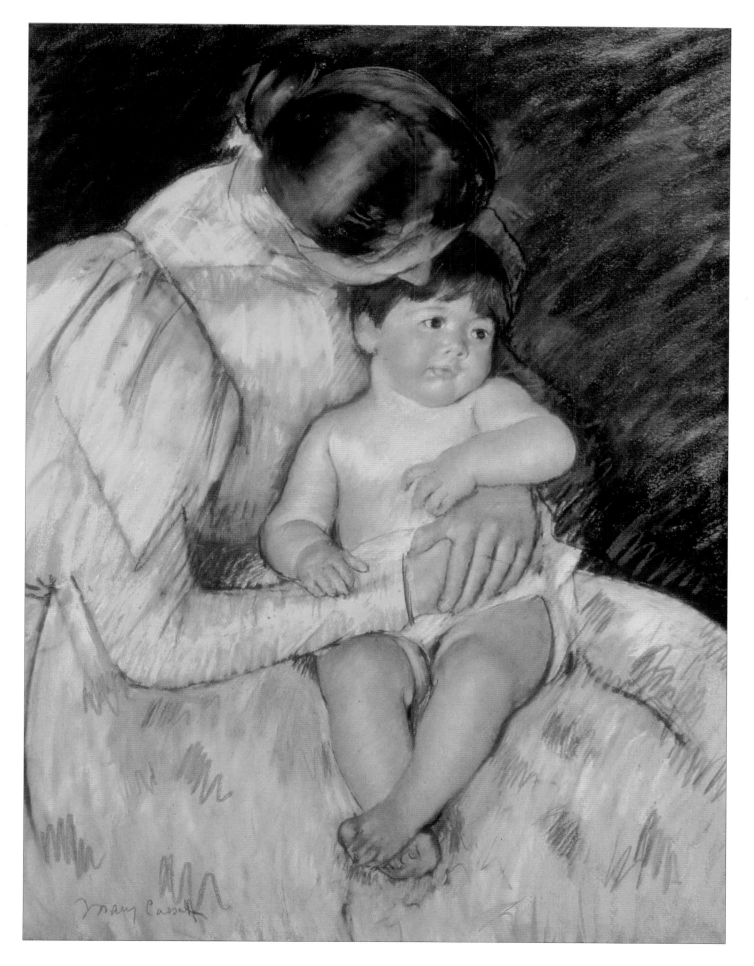

Previous page left:
Berthe Morisot (1841-94)
The Cradle 1872; Oil on canvas;
22 x 18in. (56 x 46cm.) Paris:
Musée d'Orsay. The woman and
child theme recurred often in
Berthe Morisot's work which, at
its best, was often characterized
by a very flowing, direct, freely
painted style.

Previous page right:
Mary Cassatt (1844-1926) **Child
in His Mother's Arms** Pastel;
31 3/4 x 25 1/2 in. (81 x 65cm.)
Moscow: Pushkin Museum of
Fine Arts. Tender, tranquil and
entirely free of cloying sentiment,
Mary Cassatt's many variations
of the mother and child theme
are outstanding among the
work of Impressionists in the
second half of the 19th century.
Using her own family as models
helped give Cassatt's work a
delicate intimacy.

Left:
Kate Greenaway (1846-1901)
Hush-a-Bye *c.*1900; book
illustration. Private collection.
One of the best-known of 19th-
century children's book
illustrators, London-born Kate
Greenaway gained her reputation
in British book publishing from
the late 1870s. She specialized in
drawing children in flat, delicate
colours and dressed in a style, a
blend of Jane Austen Regency
and Victorian nursery, which
became her hallmark. This
baby in a cradle was drawn for
April Baby's Book of Tunes,
published in 1900.

Vincenza Foppa's *The Young Cicero Reading*, a fresco painting of the late 15th century, is a good example from the Italian School, while Jan Steen made his usual lively addition to the Dutch School's treatment of the subject with *School for Boys and Girls*, in which most of the large crowd of boys and girls show a carefree unconcern for learning.

In France after Chardin came artists like Lépicié, with such pictures as *The Reading Lesson*, in which a young girl is guided in her study by an older woman, probably her mother, and Greuze. In *Boy with a Lesson Book*, the latter chose to abandon his usual pretty children to show a boy, dressed in a sober brown coat, concentrating on his studies.

British artists in the 19th century also often illustrated the theme of the child learning: we can actually read the title of the lesson book, *First Book of Arithmetic* in the lap of the little girl in William Bell Scott's great canvas, *The Industry of the Tyne: Iron and Coal*.

Where British artists outdid those from other schools of painting was in their depiction of the sick child. The Pre-Raphaelites and lesser genre artists, in particular, often depicted the death which was the outcome of so much childhood sickness in 19th-century Europe, when tuberculosis or diptheria could strike in any household, rich or poor. Where genre artists of the Dutch school like Gabriel Metsu, in *The Sick Child*, with its tender evocation of a mother's care for her child, had tended to set the viewer at a distance from the scene, 19th-century artists, especially the genre painters of Victorian England, with their pictures of dead children being wept over by despairing relatives, spared the viewer little.

Not all artists overdid the emotional aspects of the subject. Luke Fildes' quietly restrained *The Doctor*, which he painted because he wished to 'put on record the status of the doctor in our own time', indicated a happy ending to the illness of the child being watched over by the doctor: a dawn light is creeping into the room and the parents are depicted in an attitude of hope.

One of the most honestly distressing pictures of a sick child to come out of 19th-century art was the work of the Norwegian artist, Edvard Munch. *The Sick Child*, of which he did several versions, was Munch's way of coming to terms with the death of his 15-year-old sister from tuberculosis, a disease which also killed his mother. It was Munch, with his painting *Puberty*, who also gave European art what is probably its most emotionally charged depiction of the change from childhood to adulthood.

A sub-category of the theme of the sick child was the theme of the child orphaned by the death of its parents. A Scottish artist, Thomas Faed, made his name when he exhibited at the Royal Academy in 1855 *The Mitherless Bairn*, a variation on his painting, *The Orphans*. This picture, first shown in the year Charles Dickens' *Hard Times* was published, threw a veil of pretty sentiment over the plight of the orphaned brother and sister, depicting them as plump and pretty children, the main concession to their orphaned state being that the little girl walked barefoot.

Ford Madox Brown was more honest in his depiction of a motherless family in *Work*, his allegory of the realities of trying to find employment in Victorian England. The four children are shown as shabbily dressed, dirty, unkempt and shoeless. According to his own commentary on his painting, Brown intended the children in the painting to indicate what could happen to the children of the poor if their parents could not work, or died, or drank their earnings in the nearest drinking den.

He did allow a tone of optimism into his picture, however: the eldest girl, aged about ten, has taken well to the role of mother, keeping her younger siblings neat and tidy, while the older brother is clearly a lively, mischievous boy who looks as if he will land cheerfully on his feet in the adult world.

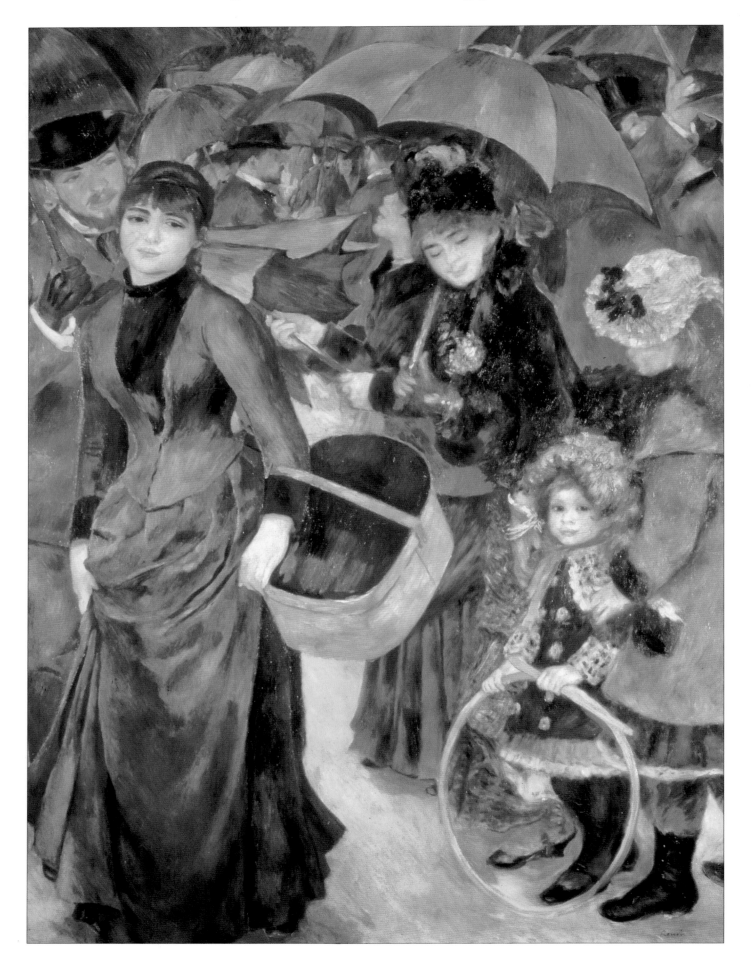

CHILDREN AT PLAY

A marked change of emphasis in the painting of children at play can be traced in art from about the mid-19th century. The great railway building boom of the period had a lot to do with it. Quite suddenly, people were being whisked away in large numbers to the country or down to the seaside. Almost as suddenly, if art is anything to go by, children were filling their leisure hours out-of-doors, often in flower-filled meadows, charming country gardens or by tree-lined riverbanks, but much more often at the seaside.

If one painting can signpost the change it is William Powell Frith's great panorama of contemporary life, *Ramsgate Sands*. Three years in the painting, the picture attracted enormous interest when it was included in the Royal Academy's Summer Exhibition in London in 1854. It was snapped up by Queen Victoria for a thousand guineas and has remained a popular item in the Royal Collection ever since. While everyone in Frith's crowded picture seems to be having a good time, it is the children who are allowed to have the most fun, pulling off their shoes and stockings to paddle in the sea, or sitting on the sands wielding spades in the building of sand castles.

From now on, the seaside would be a popular setting for painting children at play. The atmosphere of the seaside, with its salt-tanged breezes, vistas of sun-drenched, grass-fringed shorelines and vast, cloud-filled skies, allowed for the painting of splendid 'mood' pictures and virtually demanded that children should be portrayed is as informal and relaxed a way as possible.

Before long, schools of artists specializing in seascapes and beach scenes were growing up on coastlines everywhere. Eugène Boudin, an early influence on Claude Monet, lived at Honfleur on the northern coast of France, where the great vistas of the Normandy coast and sky had a profound influence on the style of his exquisite seascapes and harbour and beach scenes.

They were also to influence the work of an English artist working in the Impressionist manner, Philip Wilson Steer. One of Steer's favourite subjects was the seaside and he produced many highly coloured, sun-drenched paintings of children playing on the beach, both at Boulogne and in his home village of Walberswick on the Suffolk coast. Pictures like *Boulogne Sands*, *Walberswick: Children Paddling* and *Knucklebones* have a splendid vibrancy of colour and light which perfectly catch the pleasure of playing on the beach clearly felt by the children in the paintings.

By the 1880s, the south coast of France, with its wonderfully warm and clear light, had become even more popular with artists. Mary Cassatt's sun-

Opposite:
Pierre Auguste Renoir (1841-1919) **Les Parapluies (Umbrellas)** *c*.1884; Oil on canvas; 71 x 45 1/4in. (180 x 115cm.) London: National Gallery. For the art critic, this painting is important because it shows how far Renoir was moving from Impressionism by the mid-1880s, being intent on putting greater emphasis on a definite form and a linear pattern, while there is more than a hint of Cézanne, with whom Renoir had been working, in the way the tree and the umbrellas are painted. For the ordinary viewer, one of the great pleasures to be had from looking at this delightful painting is the discovery of the typically charming Renoir children among the umbrella-laden crowd.

Jan Miense Molenaer (*c.*1609/10-68) **Children Making Music** Oil on canvas. London: National Gallery. Married to Judith Leyster, painter of numerous fine child studies, Molenaer was a Dutch genre artist who worked mostly in Haarlem and Amsterdam. His lively style was well suited to the depiction of children.

Francisco de Goya y Lucientes (1746-1828) **Boys Blowing up a Pig's Bladder** 1777-8; Oil on canvas on cardboard; 453/4 x 487/8in. (116 x 124cm.) Madrid: Prado Museum. This lively picture was one a series of cartoons Goya produced for the tapestries made at Spain's famous royal factory of Santa Barbara.

drenched *A Ride in A Rowing Boat* (sometimes called *The Boating Party*) was painted in 1894 at Antibes, whose beach was selected by Pablo Picasso to record the activities of his own children three decades later.

In England, the fishing village of Newlyn in Cornwall gave rise to the Newlyn School of Artists after Stanhope Forbes and other artists went there in the late 1870s. Soon the seascapes, beach scenes and genre pictures of the life of fishermen and their families of the Newlyn School and their imitators and offshoots, including a group of artists at nearby Lamorna Cove, were becoming much sought-after. Many of their beach scenes included children, either young fisher lads or, very often, the artists' own children, enjoying the summer holidays.

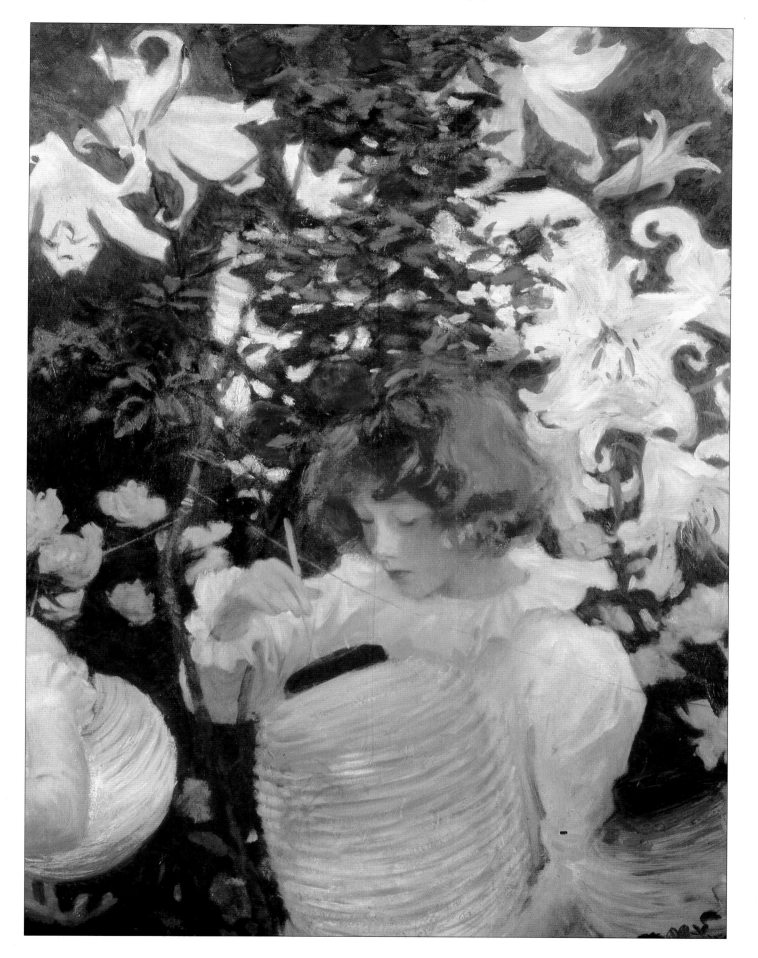

Previous page:
John Singer Sargent (1856-1925)
Carnation, Lily, Lily, Rose (detail)
1885-6; Oil on canvas;
681/2 x 601/2in. (174 x 153.7cm.)
London: Tate Gallery. Sargent
worked during two summers at
Broadway, a village in the English
Cotswolds, on this 'purely and
simply beautiful' painting, as it
was described when exhibited.
The painting took so long
because Sargent chose to work on
it only during those few minutes
in the evening when the twilight
made the flowers glow as if lit
from inside, like the Chinese
lanterns hanging among them.

Right:
Mary Cassatt (1844-1926) **A
Ride in a Rowing Boat (The
Boating Party)** 1893-4; Oil on
canvas; 351/2 x 461/8in.
(90.2 x 117.1cm.) Washington:
National Gallery of Art, Chester
Dale Collection. Cassatt painted
this technically very interesting
picture at Antibes, in the south of
France, where she had been living
for long periods for some years.
The inclusion of large, flat planes
of dark colours and the almost
abstract treatment of the sail
ensured that the painting made a
very striking centrepiece for her
first one-man show in America,
in Durand-Ruel's Gallery in New
York in 1895.

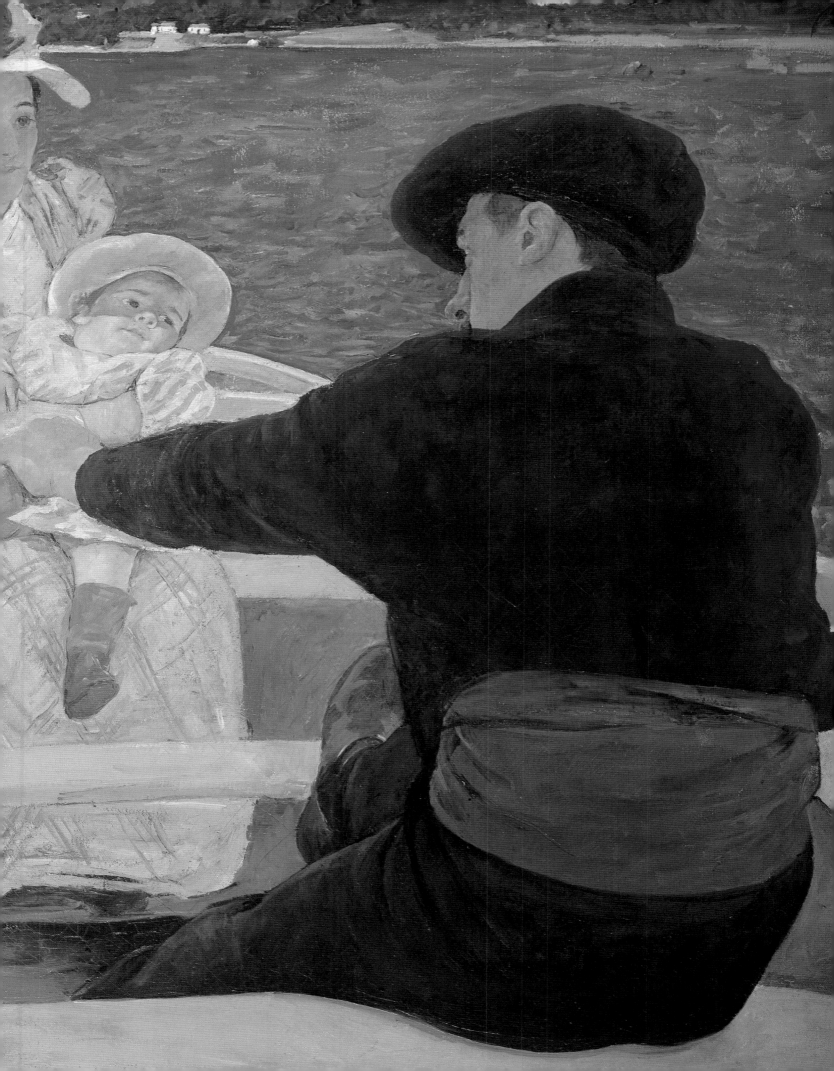

Philip Wilson Steer (1860-1942) **Boulogne Sands** 1888-91; Oil on canvas; 24 x 30in. (61 x 76cm.) London: Tate Gallery. Inspired by the work of the Impressionists, especially Monet, Wilson Steer was the first British artist to adopt fully and with great enthusiasm the Impressionist ideals of painting *en plein air* in a style full of light and using pure colours. This painting, one of many seaside scenes involving children playing on the sands which Wilson Steer did in the late 1880s and early 1890s, shows his Impressionist style at its sparkling best, full of light and air and given great vibrancy by his use of touches of white.

The United States' first important outdoor painting school was also a coastal one. It was set up in 1891 on the coast at Shinnecock on Long Island by William Merritt Chase, who, while running the Shinnecock Summer School, painted his wife and daughters in the open air, in paintings such as *Near the Beach, Shinnecock*, done in 1895.

While the seaside provided the most popular outdoors background for children at play, it was not the only one. Just as the summer garden was back in

Overleaf:
William Merritt Chase (1849-1916) **Near the Beach, Shinnecock** *c*.1895; Oil on canvas: 30 x 48 1/8 in. (76.5 x 122.7cm.) Toledo, Ohio: Toledo Museum of Art, gift of J. Secor. Against a wide horizon of sea and sky, Chase's wife and two of their three daughters stroll happily in a sunlit world, the white of their dresses echoed by the whiteness of the puffs of cloud in the sky. Chase, something of a showman among American artists at the turn of the century, set up the Shinnecock Summer Art School on Long Island in the 1890s so that he could practise and teach *en plein-air* painting.

fashion with the middle classes as a place for eating lunch and taking tea in, for playing croquet and tennis, or simply for picking flowers, so the garden became a popular setting to show children enjoying themselves.

John Everett Millais, in his fine *Autumn Leaves*, painted in Scotland in the mid-1850s, showed none of the sentimental prettiness of many of his later child studies. The four girls gathering up fallen leaves for a bonfire are set against the backdrop of a golden autumn sunset, against which tall poplars

Above:
Kate Greenaway (1846-1901)
In the Garden Book illustration.
Private collection. Taken from
a book called *A Day in a Child's
Life*, this drawing of four girls
well illustrates the Greenaway
style, based on nicely observed
detail and with the girls dressed
in a style inimitably her own.

Opposite:
Frank Benson (1862-1951) **Calm
Morning** 1904; Oil on canvas;
44 x 36in. (112.2 x 91.8cm.)
Boston: Museum of Fine Arts,
gift of Charles A. Coolidge
family. One of the founder
members of the well-known
group of American Impressionists
known as the Ten, formed in
1897, Frank Benson discovered
many outdoor subjects around
his summer home on North
Haven Island, Maine.

and a line of hills are set, their outlines softened by the sunset haze and the bonfire's smoke. It is a very fine evocation of the atmosphere of autumn.

Pierre Auguste Renoir, portraying little Mademoiselle Leclere in a picture which he called *A Girl with a Watering Can*, chose to show her in the Leclere family's garden on a sunny summer's day. Standing by a rose bush against a background of grass verge and flower bed, the little girl proudly displays her watering can and the bunch of flowers she has just picked.

One of John Singer Sargent's most famous paintings, *Carnation, Lily, Lily, Rose*, was, like Millais' *Autumn Leaves*, also set in a garden at evening. The painting is of two young girls, the daughters of an artist friend, hanging Chinese paper lanterns in a garden full of flowers. This time, however, it is high summer and one can almost believe that one can smell the heavy scents of the roses, carnations and lilies, so wonderfully evocative is the atmosphere Sargent has put into what he himself called a 'fearful difficult subject'.

While it would be wrong to over-emphasize the shift from indoor to outdoor painting of children in the mid-19th century — Goya's prolific output in late 18th-century Spain was full of wonderfully alive and action-packed pictures of children at play in the open air, and the country pursuits of England's landed gentry had naturally led to many commissions for their children in be painted with their ponies and dogs — it is still fair to say that before this many of the finest pictures of children at play showed them indoors.

A popular theme for children's pictures, as it was for grown-ups, was the making of music at home. The Dutch artist (and husband of Judith Leyster) Jan Molenaer's *Children Making Music* is an attractive early example of a theme which has recurred often in art. Nineteenth-century examples include the English painter Lord Leighton's *The Music Lesson* and Renoir's several versions of *Young Girls at the Piano*.

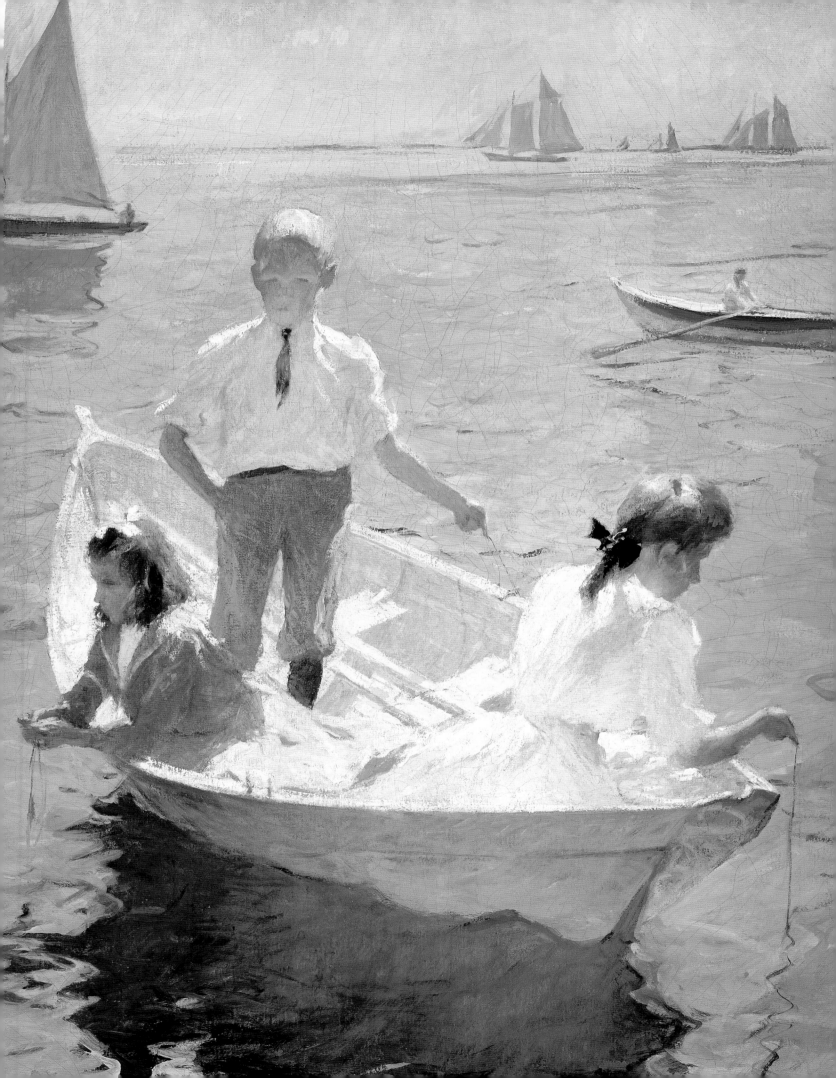

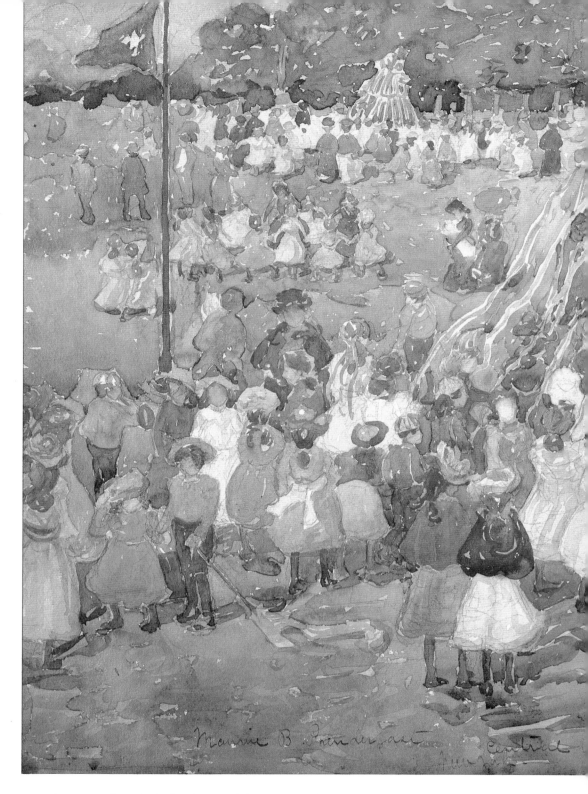

A theme with a slightly shorter life, that is, from about the early 18th century, is that of the child dressed as Pierrot, or a clown. The French artist Watteau's fascination with Italian *commedia dell'arte,* demonstrated in his many paintings including the *commedia dell'arte* 'clown' figure, Gilles (or Pierrot), influenced artists throughout Europe. One of Fragonard's most attractive child studies was of a boy dressed as Pierrot, with the familiar frilled collar providing a charming frame for the child's face.

Two artists who portrayed their own children in Pierrot's costume were Renoir and Picasso, whose pictures of his son Paulo as Pierrot and Harlequin are among his finest child studies. In a memoir of his father, published in 'Seize Aquarelles et Sanguinés de Renoir' in 1948, Renoir's son Claude, the boy who posed for *The Clown,* indicated that Renoir had taken painting his Pierrot pic-

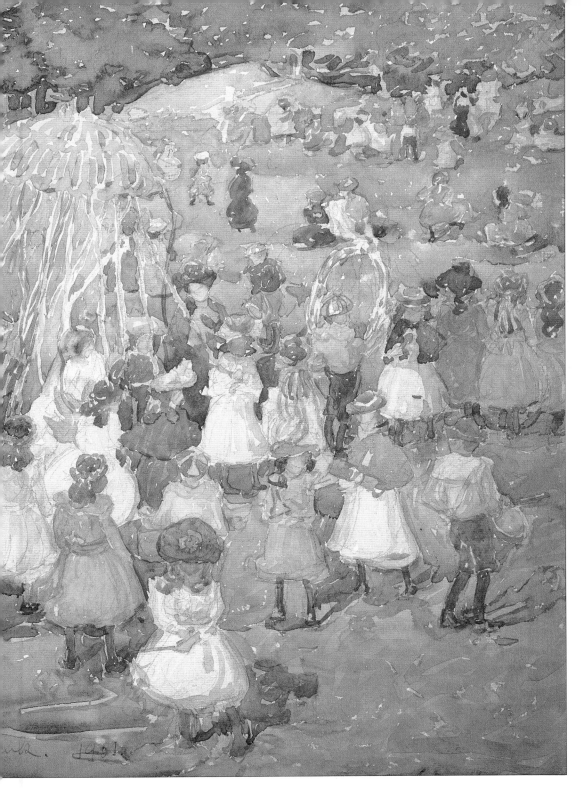

ture very seriously, insisting that for him to complete it, Claude must wear the white stockings which were part of the costume. But the stockings were prickly and the boy refused to wear them.

'Threats followed, and then negotiations; one after the other I was promised a spanking, an electric railway, being sent to a boarding school, and a box of oil colors. Finally I agreed to put on cotton stockings for a few moments; my father, holding back a rage which was ready to burst out, finished the picture despite the contortions I was making to scratch myself. The railway and the box of colors rewarded so much effort.'

It was all just another indication of why artists find children so difficult to paint — and why the fact that so many superb paintings of children exist at all is a tribute to the patience of artists as much as to their skill and genius.

Joaquín Sorolla y Bastida (1863-1923) **Children on the Beach**; Oil on canvas. Museo Del Prado, Madrid. Much admired among European artists as one of Spain's finest Impressionist painters, Valencia-born Sorolla was known particularly for the effects of sunlight which he achieved in his paintings, many of which had seaside and beach themes. This delightful painting uses the beach theme to good effect to portray a group of children enjoying life to the full.

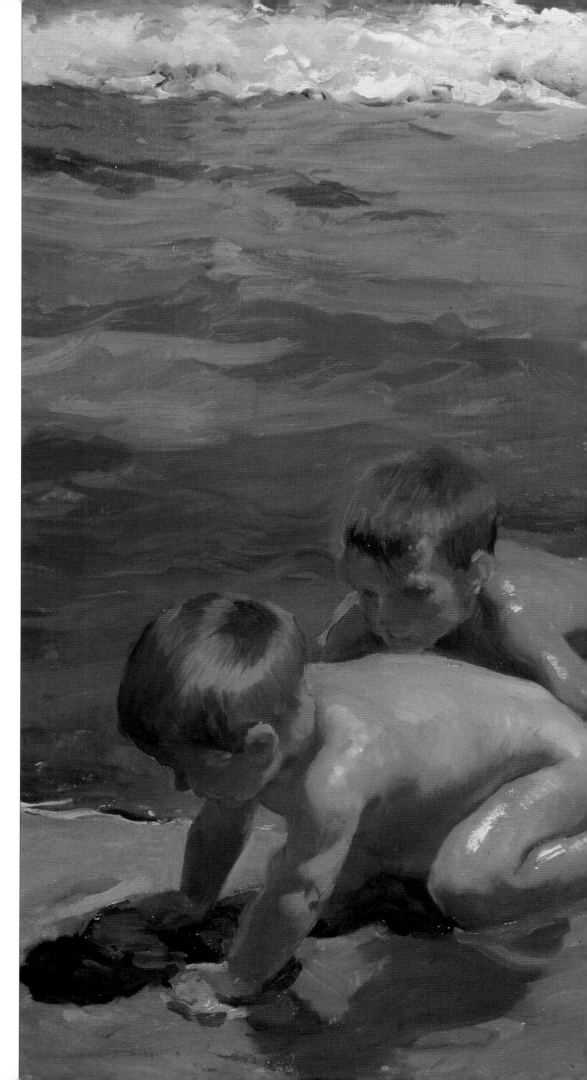

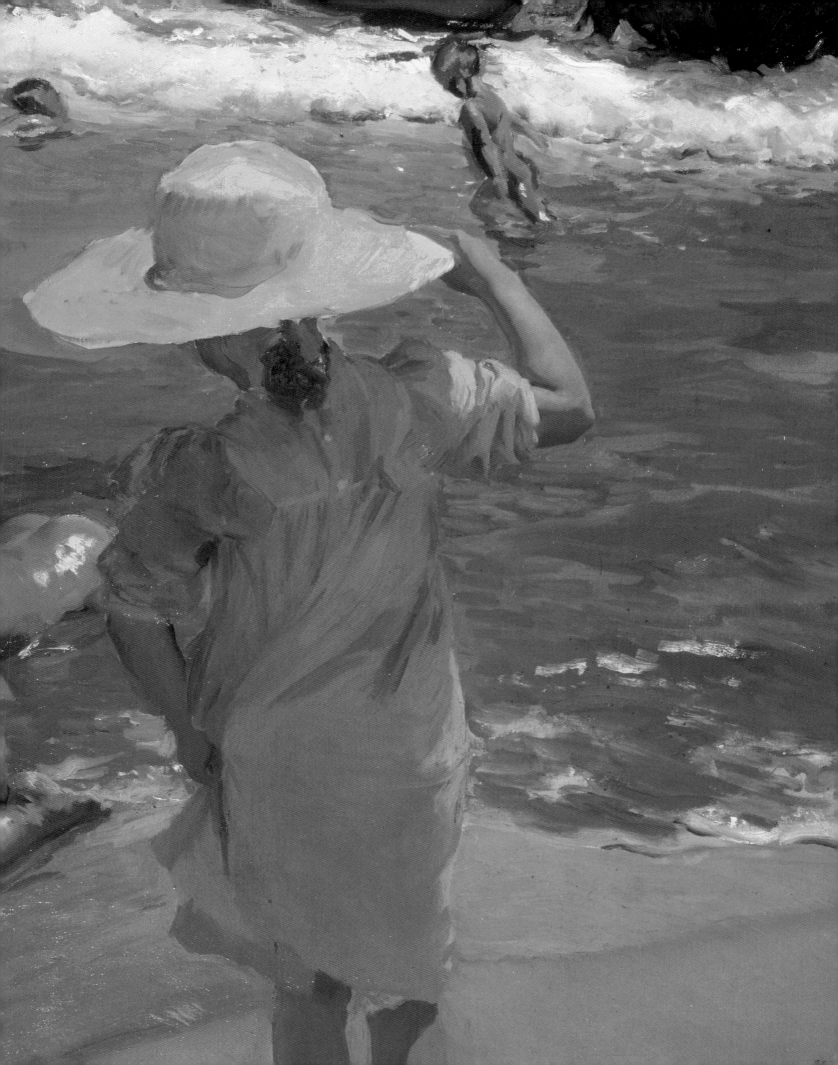

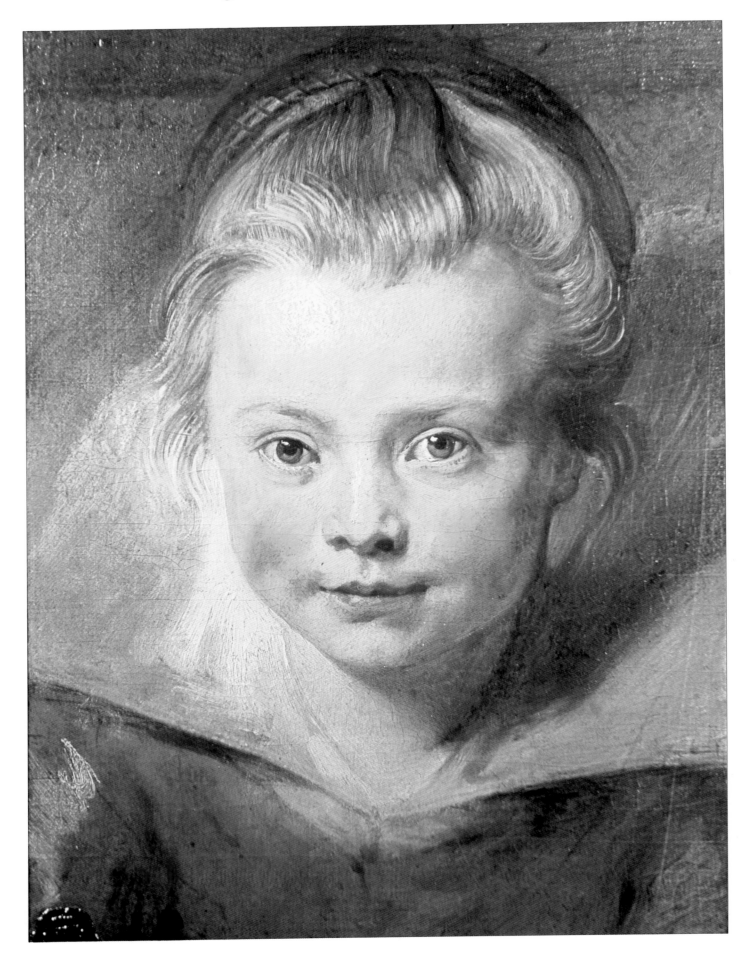

ARTISTS' CHILDREN

*P*aintings of children by their parents are among the most poignant and personal of all works of art. They are, in a sense, double portraits, one subject being the child and the other the unseen artist, whose emotional bond with the sitter is as real a presence as if he or she were in the picture, too.

This bond which makes a painting of a son or daughter so touching and compelling is expressed in the closely observed features of the child's face, in the curve of a lip, the slant of an eyelid and the subtle flesh tones which suggest the mobility of the child's face with its quick changes of expression. Setting down such details needs the acute observation of a parent, for whom the subject is not simply something to be represented as faithfully as possible but something that is a part of the artist himself.

Peter Paul Rubens, who spent so much of his time and talent in creating grandiose works for the rulers of Europe, may well have turned to the painting of his own children with relief. Twice married, Rubens delighted in the presence of young children about him and was lucky enough to have young children at home both when he was a young man and in the last decade of his life, when his idyllically happy second marriage, to the much younger Hélène Fourment, brought him five children.

Rubens' children were among his most pleasing models and he painted and drew them many times, often using the drawings as models for characters in his paintings; both his second son, Nicolas, and his youngest, Peter Paul, provided the face for the Infant Christ in Rubens' paintings, while drawings of all the boys appeared as cherubs in many paintings. No matter how many times Rubens drew and painted his children, his pictures of them were always suffused with the love and tenderness he felt for them, feelings which have never been surpassed in the painting of children.

It was another mark of Rubens' particular genius as a portrait painter that he always painted his children as individuals with their own separate identities. It was a proud and slightly amused father's eye that he turned on his two eldest sons in *The Artist's Sons, Albert and Nicolas*, painted about 1624. The elder boy, Albert, holding two books, looks at his father with the rather cocky smile of a know-everything boy verging on his teens, while Nicolas, still with the chubby

Opposite:
Peter Paul Rubens (1577-1640)
Head of a Child *c.*1618; Oil on canvas mounted on wood; 141/2 x 101/2in. (36.975 x 26.75cm.) Private collection.

Below:
Peter Paul Rubens (1577-1640)
Portrait Study of Nicolas *c.*1620; chalk, pen and ink on paper; 10 x 8ins. (25.5 x20.4cm.) Vienna: Albertina Museum.

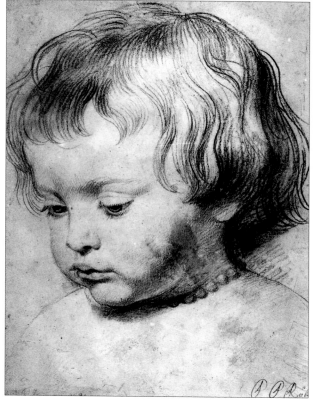

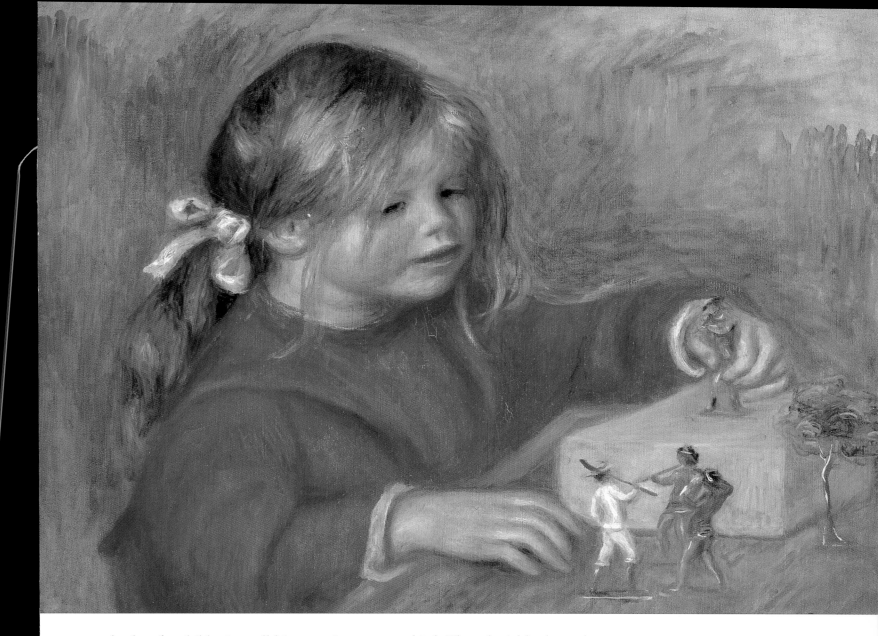

cheeks of a child, gives all his attention to a pet bird. Though richly dressed, Albert and Nicolas are boyish figures, not miniature adults.

Rembrandt van Rijn, one of the greatest of Dutch portrait painters, painted the members of his family many times, bringing to pictures of his son Titus, in particular, a loving tenderness and relaxed informality which would not have been acceptable in official or commissioned portraits. Rembrandt painted Titus in various poses, including dressed as a monk and working at his desk (with a distinctly absent-minded, faraway look on his face). It is probable that Rembrandt chose to paint his family and himself so often because it enabled him to work out problems and study effects free of the restraints imposed on having to produce portraits acceptable to his customers and patrons. That he was also painting family portraits intended to depict his deeply held feelings for them cannot be doubted, for again and again in these pictures Rembrandt displays the deep sensitivity felt by a loving father for his children.

The same sense of a loving tenderness felt for his children's youth is apparent in two charming double portraits Thomas Gainsborough did of his daughters, Mary and Margaret. *The Painter's Daughters Chasing a Butterfly* and *The Painter's Daughters Teasing a Cat* both date from the late 1750s, when the elder girl, Margaret, would not have been more than ten. In both paintings the girls are shown unsmiling and quite serious, but with a sweet tenderness in their attitude towards each other.

Knowing the family histories of artists can cause problems in responding to

Above:
Pierre Auguste Renoir (1841-1919) **Claude Renoir Playing** 1905; Oil on canvas. Paris: Museé de l'Orangerie. Claude Renoir, called 'Coco' by his family, was born in 1901, when his father was sixty. Despite his success and fame as a painter, Renoir still felt himself to be 'a simple little man'.

Opposite:
Claude Oscar Monet (1840-1926) **Jean Sleeping** 1868; Oil on canvas; 16⅝ x 19½in (42.5 x 50cm.) Copenhagen: Ny-Carlsberg-Glyptothek. Jean was Claude and Camille Monet's first child and therefore an object of special interest.

121

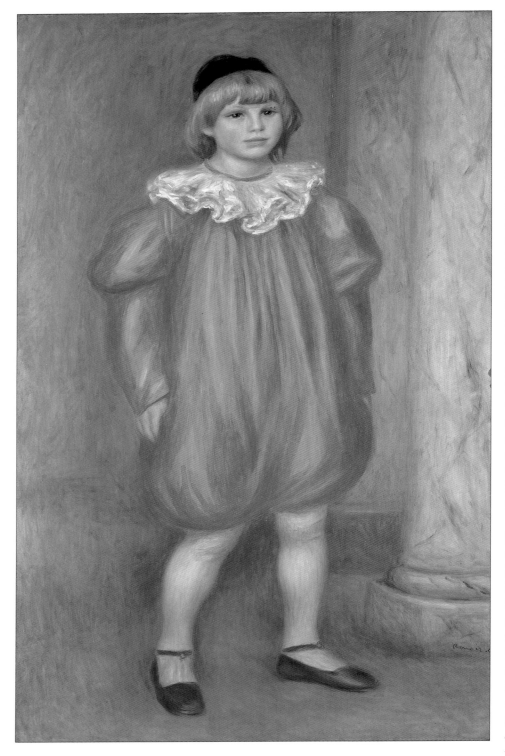

Pierre Auguste Renoir (1841-1919) **Claude Renoir as a Clown** 1909; Oil on canvas. Paris: Museé de l'Orangerie. Too young to be over-awed by his father's genius, Claude Renoir had to be bribed to wear the itchy white stockings he has on in this portrait.

their work. We know, for instance, that both Rubens and Rembrandt suffered the agony of having much loved children die in childhood; Ruben's daughter Clara Serena, model for his enchanting *A Child's Head*, died when she was 12, and two of Rembrandt's daughters died in infancy. And we know that Gainsborough had to endure the distress of seeing his daughters grow into emotionally troubled and unstable women. It is tempting to read a particularly poignant note into the artists' portrayal of their children which they never intended and which, in fact, sets us at a distance from the reality the artists were aiming at.

Even as delightfully unsentimental a portrait as Ford Madox Brown's *The English Boy*, in which he depicts his son Oliver as a rosy-cheeked five-year-old clutching a top and whip, takes on a sadness the artist never intended when we discover that Oliver, having already shown a precocious artistic talent, died at 19.

Ford Madox Brown was working at a time when great changes were coming about in society. Industrial, agricultural and political revolutions had all made the increasingly affluent middle classes influential as well. They were very much aware of the importance of the family unit and were not worried about looking unsophisticated and unworldly through devoting time and attention to their homes and children. Most artists, being themselves of the middle classes, shared these aspirations. At the same time, their traditional ways of working were changing, with fewer large public commissions to occupy much of their time. The Impressionists in France and the Pre-Raphaelites in England, in particular, tended to do more of their own thing, working within close-knit groups of family and friends.

Undoubtedly the best-known example of the artist working at his best within the bosom of his family is Pierre Auguste Renoir. Always a man of simple tastes, Renoir lived a very domesticated life in close contact with his family, which he extended to take in people like his children's nurse, Gabrielle. They all featured again and again in his work.

Because he was with them so much, Renoir was able to produce a constant stream of studies of his children in babyhood, at work and at play. His Impressionist style, with its loose brushwork, was ideally suited to the romantic, though never sentimental, view of childhood which was his greatest legacy to the world of art.

Claude Monet, another uxorious man happiest with a loving domestic background to his life, did his best paintings of his family when the children were young. One delightful study of his son Michel showed him on a mechanical horse, an attractive artefact of home life which was also a symbol of the aspirations of the French bourgeoisie.

The Impressionist style, with its loose, atmospheric appearance and undefined edges which gave portraits a romantic glow, was the accepted approach for painting children in the late 19th century, until the much more vigorous approach of artists like Pablo Picasso and Augustus John towards the painting of their own children brought about a change.

Augustus John's vigorous technique worked well in such pictures as his energetic portrait of his son Robin, with its strong brush strokes and emphatic drawing. It must be said, though, that the picture lacks the strong sense of a warm affection for the subject that Rubens or Rembrandt would have conveyed, perhaps because John's own wayward and independent nature ensured that,

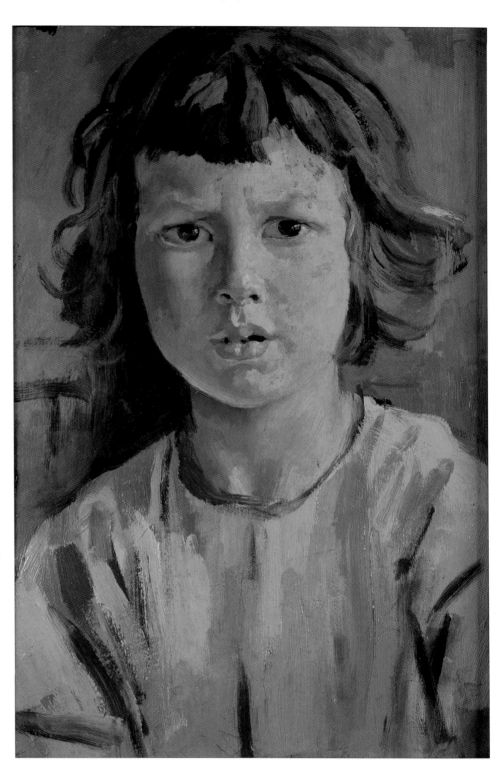

even when painting his own children, his character came to the fore.

This was a problem that Pablo Picasso, one of the greatest artists of the twentieth century, was able to overcome in his portraits of his children. Although incapable of painting anything that did not bear the force of his artistic conviction, Picasso was able to instil into his paintings of his small son Paulo the personal feeling of a strong yet tender family relationship between artist and sitter.

Paulo Picasso was born in 1921, when much of his father's work was Cubist in style. When painting three-year-old Paulo in such costumes as a bullfighter, Pierrot and Harlequin (the latter obviously growing out of Picasso's interest in

Augustus Edwin John (1878-1961) **Robin** *c.*1909; Oil on panel; 18 x 14 in. (45.9 x 35.7 cm.). London: Tate Gallery. Robin was Augustus John's third son and figured in many of the artist's paintings of his family. This portrait is a much more intimate study than his many sunlit, breezy holiday paintings.

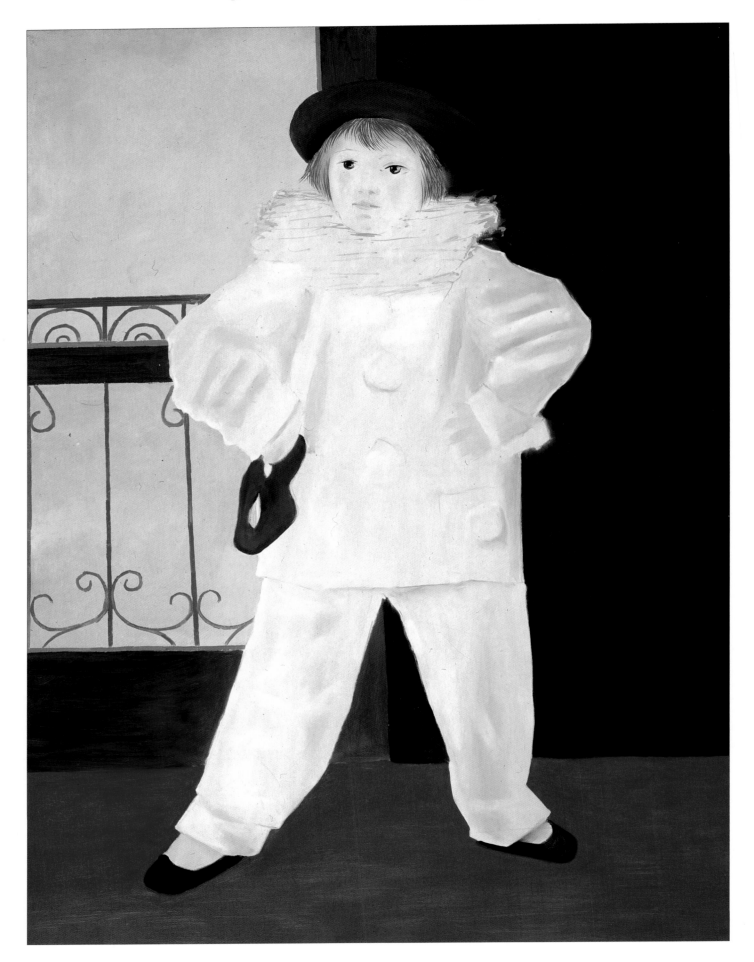

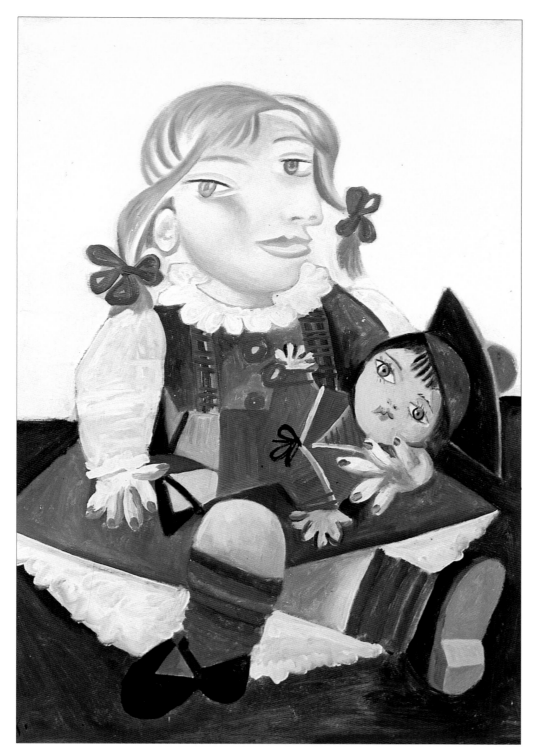

Pablo Ruiz y Picasso (1881-1973) **Maïa with a Doll** 1938; Oil on canvas; 283/4 x 235/8in. (73.5 x 60cm.) Paris: Musée Picasso. Picasso's daughter by his mistress, Marie-Thérèse Walter, Maïa was born in 1935 and so would have been about three when this painting was done. Like earlier portraits of Paulo at the same age, this was a private picture and remained in the artist's collection. This time, however, Picasso chose to approach the picture in the same style he was using for work intended for the world's art markets.

Opposite:
Pablo Ruiz y Picasso (1881-1973) **Portrait of Paulo as a Pierrot** 1924; Oil on canvas; 511/8 x 373/4in. (130 x 96cm.) Paris: Musée Picasso. Picasso's paintings of his family, especially those done in the years after the birth of his first son, Paulo, in 1921, were private things, recording with love those nearest him and done in a style far removed from the Cubism of much of his work at the time. A series of paintings of Paulo in different costumes, including two he did of him as Harlequin and a Pierrot in 1924, remained in his studio until his death.

the figures of *commedia dell'arte*), Picasso chose a realistic style. The paintings, showing all the tenderness of a father towards his child, remained in Picasso's possession; it was as if the pictures, portrayals of family life as intimate as the pages of a diary, were too personal to be sold or made public property.

Even in paintings in which the artist was intent on conveying universal truths about childhood his loving feelings towards his own children influenced his approach. Thus, paintings like *Maia with a Doll* or *Two Children* (inspecting a sea urchin on the beach) become both evocations of childhood in general and intimate studies of his own children.

\mathcal{I}NDEX

Amelia, Princess, 6, 7
Archer, James, 86, 89

Bastida, Joaquin Sorolla, 116
Beaux, Cecilia, 71,
Bellini, Jacoppo, Gentile, Giovanni, 11, 13
Benson, Frank, 115
Berruguette, Pedro, 37
Botticelli, 13
Boudin, Eugene, 101
Bromley, William, 89, 93
Brown, Ford Maddox, 98, 122
Brooke, William, 37
Bronzino, Agnolo, 28
Bruegel, Pieter & Jan, 37, 38
Burney, Fanny, 30

Cassatt, Mary, 49, 71, 77, 86, 89, 97, 101, 106
Casson, Sir Hugh, 7
Charles V, Emperor, 33
Chase, William Merritt, 108, 109
Chardin, Jean-Baptiste, 58, 65, 86, 93, 98
Copley, John Singleton, 30
Crivelli, Carlo, 9
Cumberland, Duke of, 7

Dahl, Michael, 7
des Granges, David, 44
da Vinci, Leonardo, 10, 11, 17
Denning, Stephen Poyntz, 34
Dickens, Charles, 17, 98
Dolce, Ludovico, 13

Eastlake, Sir Charles, 18
Elizabeth I, 30
Eworth, Hans, 56

Faed, Thomas, 98
Farnese, Ranuccio, 33
Fildes, Luke, 98
Forbes, Stanhope, 104
Foppa, Vincenza, 98
Fragonard, Jean Honoré, 65, 114
Frère, Pierre Edouard, 86
Frith, William POwell, 101

Gainsborough, Thomas, 65, 77, 121
Gaugin, Paul, 77
Gonzaga, Ludovico, 21
Goya, Francisco, 33, 34, 104
Greenaway, Kate, 97, 112
Greuze, Jean-PBaptiste, 63, 65, 73, 98

Hals, Frans, 39, 55
Hermitage Museum, St Petersburg, 10
Holbein, Hans, the Younger, 21, 33
Hogarth, William, 45, 59, 71
Hooch, Pieter de, 39, 40, 81
Huysmans, Joris-Karl, 86

John, Augustus, 52, 23
Johnson, Cornelius, 44
Jordaens, Jacob, 13

Landseer, Sir Edward, 34
Largillière, Nicholas de, 30
Lawrence, Thomas, 7
Leighton, Lord, 112
Lépicié, Nicolas-Bernard, 81, 86, 98
Leyster, Judith, 55
Lippi, Fra Filippo, 9, 13
Lippi, Filippino, 9

Maes, Nicolaes, 18, 39
Manet, Edouard, 45, 49
Mantegna, Andrea, 13, 21
Medici, 21, 28
Metsu, Gabriel, 98
Millais, John Everett, 17, 18, 19, 65, 77, 89, 121, 123
Miller, Oliver, 44
Modigliani, Amedeo, 77, 78
Molenaer, Jan, 55, 103, 112
Monet, Claude Oscar, 49, 50, 68, 89, 121, 123
Morisot, Berthe 89, 97
Murillo, 17, 59, 63
Munch, Edvard, 98

National Gallery, London, 11
National Gallery, Scotland, 13

Perroneau, Jean-Baptiste, 63
Picasso, Pablo Ruiz, 77, 104, 114, 123, 125
Pissaro, Camille, 93
Prado Museum, Madrid, 17
Prendergast, Maurice, 112

Raphael, 13, 17, Rembrandt van Rijn, 17, 28, 38, 55, 58, 121
Renoir, Claude, 7, 114

Renoir, Auguste, 7, 45, 49, 68, 77, 89, 93, 101, 112, 114, 121, 122
Reynolds, Joshua, 45, 63, 71, 73
Royal Academy, 18
Rubens, Peter Paul, 14, 17, 28, 33, 37, 39, 44, 81, 119

Sacra Conversazione, 9, 11
Sargeant, John Singer, 74, 106, 112
Seurat, Georges, 73
Steen, Jan, 39, 40, 81
Steer, Philip Wilson, 101, 108
Sully, Thomas, 68

Titian, 17, 24, 28

Uffizi Gallery, 9

Valázquez, 17, 28, 34
Vandramin family, 33
Van Dyke, Anthony, 6, 7, 24, 33, 44
Van Gogh, Vincent, 71, 77
Van Oost, Jacob, the Elder, 55
Van Somer, Paul, 24
Van Noort, Joan, 55
Vasari, Giorgio, 21
Venice, 10

Watteau, 114
Winterhalter, Frans Xavier, 34

PICTURE CREDITS